WORDS WITHOUT MEANING, MEANING WITHOUT WORDS

ASIAN ART & CULTURE

Published by the

Arthur M. Sackler Gallery

Smithsonian Institution, Washington, D.C.

and the

University of Washington Press

Seattle and London

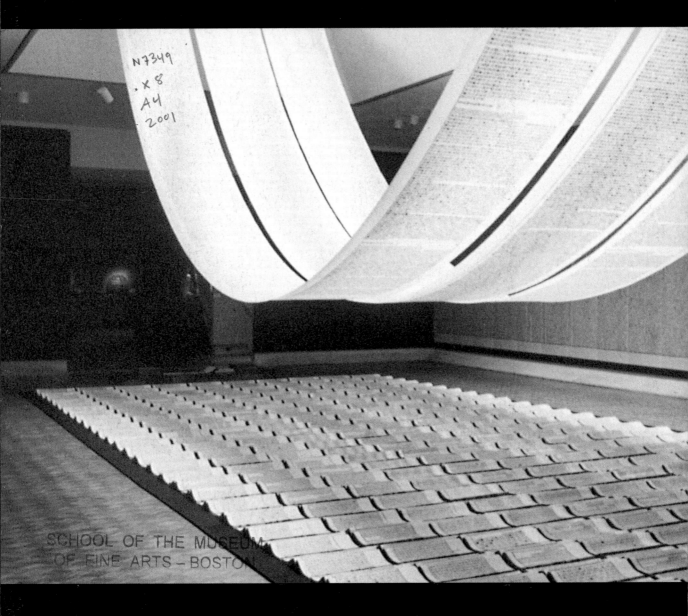

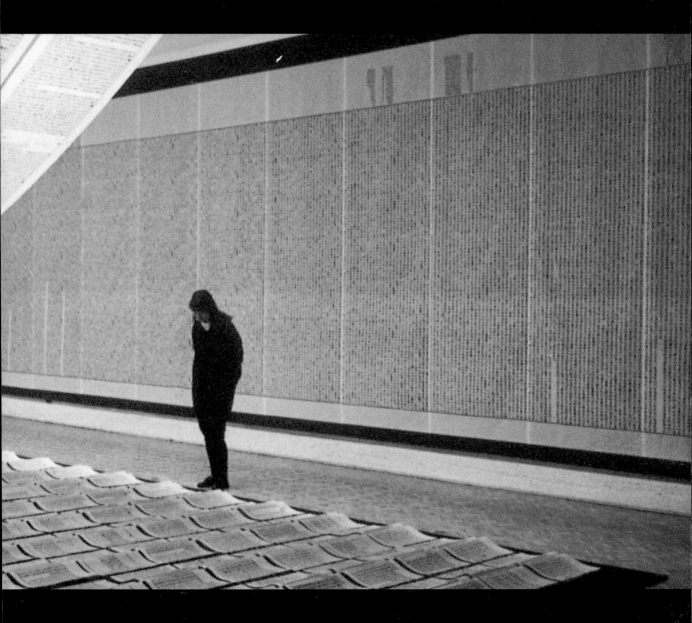

Published as part of the Asian Art & Culture series by the
Arthur M. Sackler Gallery, Smithsonian Institution,
Washington, D.C., in association with the
University of Washington Press, Seattle and London

This publication was supported in part by the Donald R.
Ellegood International Publications Endowment.

Karen Sagstetter: Head of publications and
editor of the Asian Art & Culture series
Nancy Eickel: Editor
Carol Beehler: Designer
Typeset in The Mix
Printed in Hong Kong

Cover: Xu Bing's signature in Square Word Calligraphy,
2001. Ink on paper. Courtesy of the artist.
Frontispiece: *Book from the Sky.* Installation view from
the exhibition *Three Installations by Xu Bing* at the
Elvehjem Museum of Art, University of Wisconsin-
Madison, November 20, 1991, to January 19, 1992.
Photograph by Greg Anderson. Photograph courtesy of
and reproduced with permission of Elvehjem Museum
of Art, University of Wisconsin-Madison.

Unless otherwise noted, all works and photographs are
by Xu Bing (© 2001).

Library of Congress Cataloging-in-Publication Data
Erickson, Britta
The art of Xu Bing: words without meaning, meaning
without words / Britta Erickson.
p. cm. – (Asian art and culture)
Published to coincide with exhibition at the
Sackler Gallery.
ISBN 0-295-98143-1 (soft cover: alk. paper)
1. Xu, Bing, 1955 — Exhibitions. I. Xu, Bing, 1955 —
II. Arthur M. Sackler Gallery (Smithsonian Institution)
III. Title. IV. Asian art & culture (numbered)
N7349.X8 A4 2001
709'.2-dc21 2001035594

The paper used in this publication meets the minimum
requirements for the American Standards for
Permanence of Paper for Printed Library Materials

Smithsonian
Freer Gallery of Art and
Arthur M. Sackler Gallery

CONTENTS

fOR the vast majority of museum audiences in the West, Chinese art is viewed almost exclusively as one of the past, a long ago and faraway glory that rarely intrudes on the present. Space, time, and above all, history and language have conspired to keep China and its art at arm's length — acknowledged, often admired, but hardly understood since, conventional wisdom relentlessly tells us, modern and Chinese are oxymoronic when it comes to the visual arts. That divide is now being bridged in unexpected ways.

Seeming to arrive with surprising speed and numbers, new art and new artists from China appeared to catch the Western art establishment and its critical advocates off guard in the early 1990s. Flaunting a penchant for new forms and materials, the reinvention of artistic languages and a self-conscious distancing from other major traditions in contemporary Chinese art, this "experimental art" *(shiyan meishu)* actually has deep roots that reach back to the 1970s in China. Shunning academic and official art as well as popular urban visual culture and gallery-driven "international" art, these Chinese artists are now regarded as major forces in the art of this century, in both the West and China.[1]

Foreword

THOMAS W. LENTZ

Director, International Art Museums Division
Smithsonian Institution

While many remain to work in China, an increasing number of Chinese artists, such as Gu Wenda and Cai Guoqiang, among others, have emigrated to the West, where they now find growing acclaim on both popular and critical fronts. All to some extent exploit the contradictions and pressure points inherent in cross-cultural investigation, but one in particular — Xu Bing — has imaginatively attacked the most formidable of barriers for Western audiences: language. The subject and the artist are particularly apt for the Smithsonian's Freer Gallery of Art and Arthur M. Sackler Gallery. As the national museum of Asian art for the United States, not only does it hold one of the largest repositories of Chinese calligraphy in the country, but it also is charged through its exhibitions, collections, research, and publication programs to explore the power, mysteries, and complexities of a writing system that historically has dominated East Asia.

The Art of Xu Bing: Words without Meaning, Meaning without Words is the fifth volume in the series Asian Art & Culture and coincides with a Sackler Gallery exhibition that probes the ways Asia and the West visually interact. An artist of protean range and dimension, Xu Bing has at his disposal a formidable array of means by which he untangles the increasingly hybrid cultures that now envelop our lives and

Page 6: Detail, *Quotations from Mao Zedong: Talks at the Yanan Forum on Literature and Art,* 2000. Ink on paper, 67.3 x 175.2 cm. Courtesy of Ethan Cohen Fine Arts and The Bob Ruenitz / Jeri Hamilton Collection.

much of the world. If, as Xu Bing contends, the endless stress and absurdities of linguistic interchange and relationship are universal in nature, then what makes him and his language-based investigations unique is an ability to lay them bare with startling ease and complexity. By transforming his own personal experiences with intellectual rigor, an intensely disciplined craftsmanship, and a sly, subverting humor, his art in large part resides in a capacity to speak to everyone in universal terms.

Milo Beach, Director, Freer Gallery of Art and the Arthur M. Sackler Gallery, deserves thanks for his unwavering support of this project. But above all it is Britta Erickson, exhibition curator and independent scholar, who has eloquently provided the framework for understanding Xu Bing's work. Her knowledge of both modern and contemporary Chinese history and art history, as well as contemporary art in the West, provides the platform from which Xu Bing's intentions are clearly illuminated. The museum and the Smithsonian owe her a debt of gratitude. We are grateful to the Friends of the Freer and Sackler Galleries, the Blakemore Foundation, H. Christopher Luce, and the Ellen Bayard Weedon Foundation, whose support helped make the Xu Bing exhibition possible. Significant funds were also made available by the Smithsonian's Special Exhibition Fund and the Gallery's Else Sackler Public Affairs Endowment.

In a final twist both fitting and ironic, Washington now joins Beijing as a site of activity, experimentation, and reflection for Xu Bing. In both capitals, history and language have always weighed heavily on all discourse, and neither is unaware of the fact that "official" thinking often stifles and excludes new ideas or new ways of seeing the world. Xu Bing is here to help.

NOTE

1 Wu Hung, *Exhibiting Experimental Art in China* (Chicago: David and Alfred Smart Museum of Art, University of Chicago, 2000), pp. 11–18.

t HIS BOOK, focusing as it does on an individual, would have been absolutely impossible without the cooperation of its subject, Xu Bing, who patiently and diligently answered my questions, including those that may have seemed irrelevant or obtuse. He amiably assisted with the task of researching his early life, enlisting the help of family, friends, and former students when I required photographs or additional information. For this I am grateful to Xu Bing, his mother, and others who contributed in this way.

For their long-term moral support, I thank my husband Jim Ferrell and my undergraduate advisor Michael Sullivan. Their support is notable because fifteen years ago, when I first decided to focus my research on contemporary Chinese art, many people informed me that I was crazy: there was no contemporary Chinese art worthy of note! More recently, Richard Vinograd has encouraged my endeavors in this field.

Acknowledgments

BRITTA ERICKSON

For introducing me to Xu Bing and inviting me to write the catalogue for the artist's first solo exhibition in the United States, I thank Russell Panczenko. Thomas W. Lentz, former deputy director of the Freer and Sackler Galleries, played a most crucial role in the development of this book: his enthusiastic response to my proposal for the 2001 exhibition at the Arthur M. Sackler Gallery *(Word Play: Installation Art by Xu Bing)* included the suggestion that I write this book. I thank him for that as well as for his continued support.

To the staff of the Freer and Sackler publications department I owe thanks for their encouraging words as this book progressed, and for their attention to detail as the book reached its final form. In particular, I thank Karen Sagstetter, head of publications, and Nancy Eickel, editor, for the least painful and most educational editing process in my experience, and Carol Beehler, art director for publications, for an imaginative design that truly showcases the artist's work. Exhibitions coordinator Cheryl Sobas's diligence and efficiency also contributed greatly to the success of the project.

Finally, I thank the individuals and institutions who provided photographs and other materials for this book.

FROM his extraordinarily accurate rendering of *Michelangelo's David* (fig. 1) to the installation *Panda Zoo* (fig. 2), the career of Xu Bing (born 1955) evolved dramatically since the mid-1980s. The drawing of *Michelangelo's David*, completed during Xu Bing's first year as a student in the Central Academy of Fine Arts in Beijing, was held up as a model for years. Here was a young star of the Chinese art establishment. *Panda Zoo*, distant from the drawing in style and conception, belongs to another world—that of the international art elite. Linking the two is one constant: with every finished work of art, Xu Bing aims for perfect execution. *Michelangelo's David* is characteristic of Xu Bing's drive to succeed within the system to which he was bound. Now that that system no longer constrains him, he exposes the limitations inherent in his current situation in *Panda Zoo*. Can people in the West learn to look beyond superficial Chinese characteristics to see what lies beneath? (Can they see past the cute "panda" to recognize the pig?)

Introduction

BRITTA ERICKSON

I met Xu Bing in 1990, soon after he had moved from Beijing to the United States. His 1989 installation, the *Book from the Sky*, had caused a sensation in Beijing, and the government had singled it out for harsh criticism. Fortuitously, the University of Wisconsin-Madison invited him to accept a position as Honorary Fellow, and he decided to take advantage of that opportunity to escape from the negative atmosphere in Beijing. Since then, Xu Bing has become an internationally renowned artist, and his work is sought for major exhibitions throughout the world. He returns regularly to Beijing but is based in New York. In 1999 the MacArthur Foundation awarded him a fellowship.

Xu Bing's oeuvre is incredibly rich and varied. As a student he mastered the socialist realist style of drawing, but he soon turned aside to create a series of charming and simple woodcuts. Later he redirected his talent as a print artist to create the monolithic *Book from the Sky*, an installation of books, scrolls, and panels printed with invented characters that he carved himself. The nihilism and obscurity of the piece drew the Chinese government's condemnation. In the late 1980s, installation art had only just begun to appear in China. Now it has become the dominant format for Xu Bing's art.

Much of Xu Bing's oeuvre deals with issues relating to language or to being human—issues that can be tightly intertwined. He has discovered how to lead people to learning about their own natures by confronting them with unexpected situations. For example, museum visitors are drawn to read a text the artist has put on display, only to find the text is impossible to read. His audience is forced to reconsider

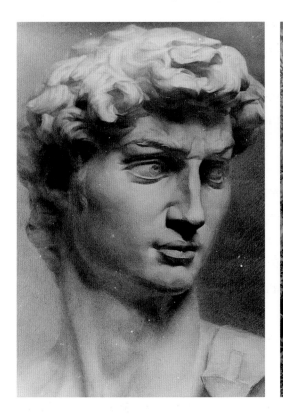

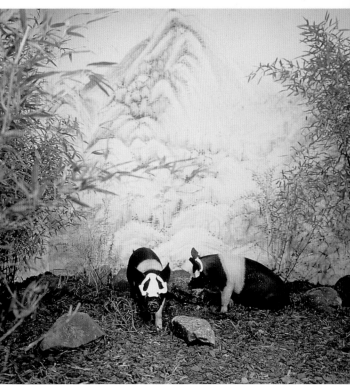

their assumptions about the value and reliability of the written word. Or he may invite them to experiment with calligraphy, which they assume to be Chinese, but they eventually discover it to be English written in a new style. He has staged performances featuring animals, luring his audience into considering uncomfortable facts about human nature. The effectiveness of these works of art and the reason they can convey profound messages without seeming pedantic lie in Xu Bing's ability to engineer situations in which each member of the audience can arrive at a revelation at his or her own pace.

In writing this book, I have identified several themes that run through Xu Bing's work, and I have devoted a chapter to each theme. To some extent, the themes correlate to distinct phases of the artist's life, but there is overlap. I have accumulated much of the information in this book over the course of many years of casual conversations with Xu Bing. I feel fortunate to know Xu Bing, and I am grateful to him for sharing his memories and records of his early years with me, thus allowing this book to start where it rightfully should, with his life in Beijing.

1 *Michelangelo's David*, 1977. Pencil sketch, size unknown. Now destroyed.

2 *Panda Zoo*, 1998. Installation with pigs, leather masks, bamboo. Installation view from an exhibition at Jack Tilton Gallery, New York, September 10 to October 10, 1998. Photograph by Peter Bellamy. Photograph courtesy of and reproduced with permission of the Jack Tilton Gallery.

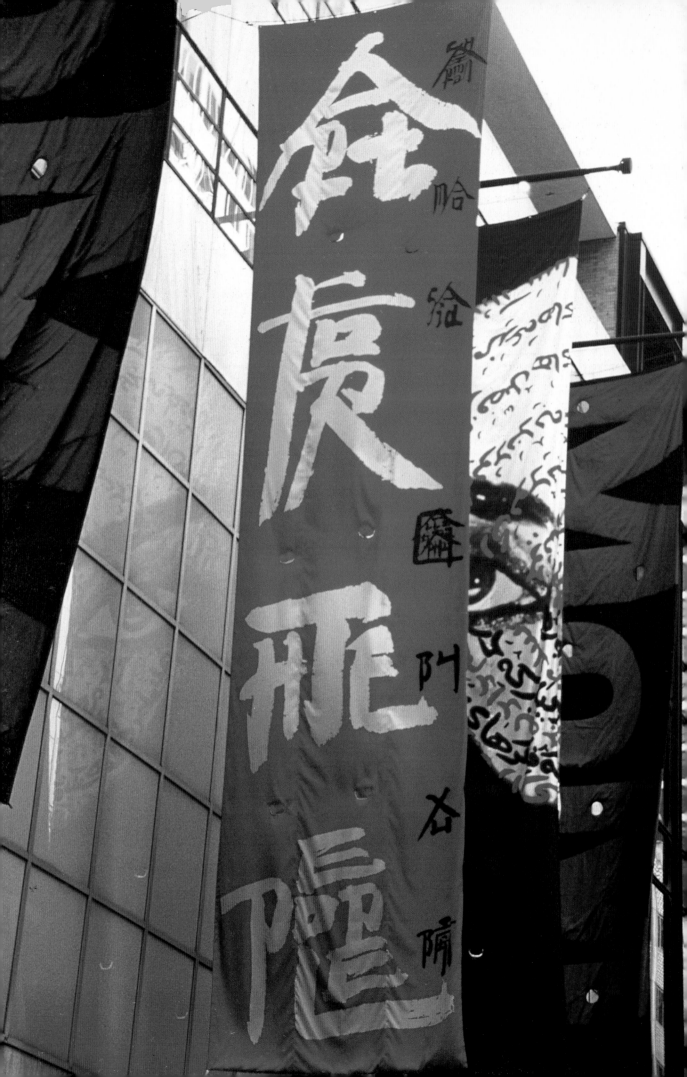

MANY strange dialogues are recorded in the annals of Chan (Zen) Buddhism. In the *Collected Works of Buddhism* is the question, "What is Buddha?" The master responds: "The neigh of a wooden horse." How could the Buddha be the neigh of a wooden horse? A student might ponder this all day without coming to a conclusion, yet perhaps the day will come when he "suddenly bumps upon the proper road and realizes what has been clouding his vision." Such "sudden realization" in Chan Buddhism is called Enlightenment. This Chan method of revelation can lead you to understand the errors in your thinking and everyday logic. The real origins of truth cannot be found in a literal, logical answer but instead must be "searched for in the living word." Buddhists believe that "if you look for harmony in the living word, then you will be able to reach Buddha; if you look for harmony in lifeless sentences, you will be unable to save yourself."

The Living Word

XU BING
TRANSLATED BY ANN L. HUSS

The complicated lives and cultural experiences of my generation of mainland Chinese have verged on the absurd. Society has constantly presented us with extraordinary difficulties. We have had to face them and find effective responses. My work and my method of thinking have been my "search for the living word," my response to the realities of the past and my own cultural experiences.

Our lives and cultural background are a jumbled knot of socialism, the Cultural Revolution, the Reform Period, Westernization, modernization—all these complexities are reflected quite naturally in my work (fig. 3). For example, when I began using so-called modern language in my work, people noted a strong element of traditional culture and "bookishness." Even when I had completed some extremely experimental works with living animals, the same classic sensibility pervaded.

From where does this bookishness come? In reality, members of my generation were never truly educated in orthodox Chinese culture. Much of what we learned was remolded by Mao Zedong (1893–1976). Mao hoped to create a new culture that dispensed with the old but at the same time was not Western. This sort of change formed an extremely important part of our cultural background. It influenced our modes of thinking and even speaking. The mainland China of the past was closed, but it was not traditional. This is a particularly interesting reality, and we must decide how to confront it.

Mao's transformation of culture was meant to "touch people to their very souls." Most deeply rooted was his transformation of language, because the Chinese

language directly influences the methods of thinking and understanding of all Chinese people. To strike at the written word is to strike at the very essence of the culture. Any doctoring of the written word becomes in itself a transformation of the most inherent portion of a person's thinking. My experience with the written word has allowed me to understand this.

When each member of the Chinese cultural community first begins his or her education, he or she must spend years memorizing thousands of characters. This process is a sort of ceremony in homage to the culture, and it leaves all Chinese with an extreme sense of respect for the "written word." My generation, however, was irreparably affected by the campaign to simplify characters. This remolding of my earliest memories—the promulgation of new character after new character, the abandonment of old characters that I had already mastered, the transformation of new characters and their eventual demise, the revival of old characters—shadowed my earliest education and left me confused about the fundamental conceptions of culture.

In my own personal experience, this feeling of a culture being turned upside down was particularly pronounced. My parents worked on a university campus—my father was in the department of history and my mother worked in the department of library sciences—and I became familiar with all sorts of books at a very early age. But books seemed strange to me then because I could not read them—I was too young. And when I finally *could* read them, I was not *allowed* to read them. These were the years when we could no longer read whatever we chose. We read Mao's "Little Red Book." After the Cultural Revolution, I returned to the libraries to read or skim book after book. Before long, China began to experience a "cultural warming." I read so much and participated in so many conversations on culture that my mind was in a constant state of chaos. My psyche had been clogged with all sorts of random things. I felt as if I had lost something. I felt the discomfort of a person suffering from starvation who had just gorged himself. It was at that point that I considered creating a book of my own that might mirror my feelings (the *Book from the Sky*). And then, already past thirty-five, I moved to the United States and began learning yet another way of speaking and writing. Traces of the conflict that arose between my actual level of knowledge and my ability to express that knowledge can be found in my later works.

Throughout my life, I have always felt that I am incapable of entering culture, and at the same time I am unable to escape it. I

3 page 12, "Art for the People" banner, written in Square Word Calligraphy, 1999. Dye sublimation on dacron polyester, 109.73 x 27.43 m. Installation view from the exhibition *Projects 70: Shirin Neshat, Simon Patterson, Xu Bing*, at the Museum of Modern Art, New York, November 22, 1999, to May 1, 2000. Reproduced with permission of the Museum of Modern Art.

4 The character *qi* (above) turning into *gou* (below). (The surname turned on its side becomes "dog" as a way to insult.)

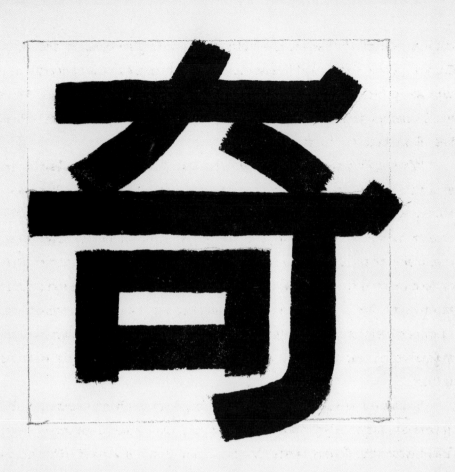

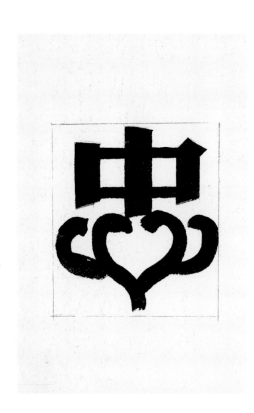

5 *Zhong* (loyal) rendered as a half-modern, half-ancient character-drawing.

have been around lots of books, but I never once read one closely. I am not a cultured person, but I know my fair share of words. When I was young, my father required that I write a page of characters each day. In the beginning, I would trace red characters in books like the *Square Word Calligraphy Red Line Tracing Book* that I use in *Classroom Calligraphy*. Later I would practice copying calligraphy with rubbings from famous classical stelae as my models. A calligrapher must sit up straight and show great concentration. Eventually this became both a habit and an interest of mine. Even when I was sent to work on a production team in the countryside, I continued to practice calligraphy from time to time. This was an unusual practice during that period. In the Asian world of letters there is a thing called *tongzi gong*, or precocious skill. It might be said that I had such a skill, yet in my mind I have never truly created calligraphy, because my earliest experience with the brush—the tracing of red characters and the copying of classical stelae—was not calligraphy: it was simply writing characters. To be precise, it was a method of cultural conditioning and a rite of cultural passage. I never thought of it as art.

This skill of mine came of use during the Cultural Revolution. I found that an element of traditional culture could be used to revolutionize one's fate, somewhat like my later works. At the time there was a saying: "Use your pen as your weapon and shoot down reactionary gangs." My father was a reactionary. No one spoke of "tradition" during the Cultural Revolution; instead we spoke of "blood relationships." I was labeled "the bastard son of a reactionary father." My family background was polluted, but I could write well, so I was grudgingly allowed to become a useful person, a "writing tool." To be honest, I am very resourceful, but at that time all I could manage to do was what I do well in order to rid myself of my blemished family history. I sat in the Propaganda Office for hour upon hour, writing and painting. Big character posters and leaflets made of tightly written small characters, they all were as carefully and neatly done as professionally printed words. Even the largest slogan posters were perfect on first try. Each character was standard and forceful. I could write them quickly and extremely well. I have written so much, and now as I think back, it seems as if I was then like the Buddhist copiers of old. They did not need to understand the meaning of each sutra that they copied. They had only to copy and recopy a lifetime's

worth of sutras to gain entrance into the next world.

I say that preparing all those posters was like copying sutras because, although it was very difficult work, I was very willing to do it. Dedication to a particular action is part of my personality. I research new fonts that appear in newspapers, and I pay attention to new forms of writing. For example, one can turn the character *qi* in the name of one of China's famed leaders, Liu Shaoqi (1898–1969), on its side to become *gou,* or "dog," but the character is still read as *qi* (fig. 4). In writing the compound character *zhong,* meaning loyal, you can combine in one character the ancient and modern forms of the Chinese language. The lower half of *zhong* is the heart radical, which can be written in pictographic form so that it resembles an actual heart (fig. 5). The *zhong* radical, written in its modern form, acts as the phoneme. Ancient and modern aspects of the Chinese language can thus be fused to create signs of interesting and provocative

6 Cover of the first *Lanman shanhua* newsletter, no. 1, 1975. Paper. 26.7 x 19.4 cm.

form and meaning. Pasting such creatively written characters all over a room's four walls results in the equivalent of a modern installation. Chinese people did this type of creative linguistic manipulation—writing *dog* in Liu Shaoqi's name to declare hatred of him, or emphasizing the heart shape in the character *zhong* to express dedication to Chairman Mao—to show their extreme emotions during turbulent times.

Later I was sent to the countryside as part of Mao's rustication program. In an impoverished, remote village, I became a "scholar." Besides writing posters and printing newspapers (fig. 6), I became expert at making decorative banners for weddings, funerals, and holidays. At the New Year, the villagers requested that I combine the four characters in the phrase *Huang jin wan liang* (Ten thousand catties of gold) to form a single character (fig. 7). They also asked me to write *Zhao cai jin bao* (Bringing in wealth and riches) as a single character (fig. 8). When someone died, I was asked to string together a series of strange characters to form what looked like a stream in the nether world. The uniqueness of Chinese characters has encouraged a tradition of "playing upon words" since time immemorial. That village was quite remote, so it still maintained many of the old customs.

Rarely in the turbulent, ever-changing reality of modern Chinese society can a person read with dedication. Those who truly understand the meaning of reading will

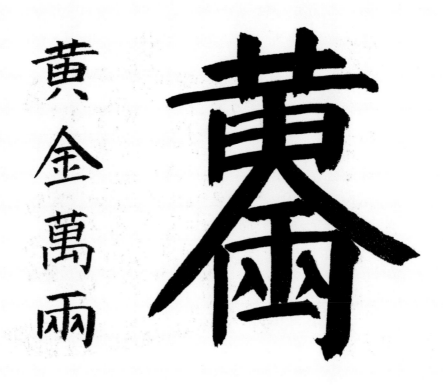

7 *Huang jin wan liang* (Ten thousand catties of gold) rendered as in folk art.

know how to "read" into the rich text that is Chinese society. This tremendous "volume" is as difficult to interpret as the famous Chan texts. You must be able to find your way through the emptiness and locate meaning in the midst of chaos. You must use Chan methods to gain understanding.

Years ago when I carved the *Book from the Sky,* friends said that there was something wrong with me. They had become accustomed to a deviant society, but they were not used to employing atypical methods to respond to that society. Now that I have written these words that both are and are not English words (Square Word Calligraphy), friends say that the feeling is right. I think my friends understand me. Their response tells me that not only does this method suit me from a technical perspective, but also, more importantly, these characters hint at something that is very much like me and my state of mind.

I love using the written word to create works of art. My creations are words and yet simultaneously are not words. They look familiar, but you cannot name them. They have been disguised to look different internally and externally.

These masked "words," like computer viruses, have a purpose in the human mind. In the space between understanding and misunderstanding, as concepts are

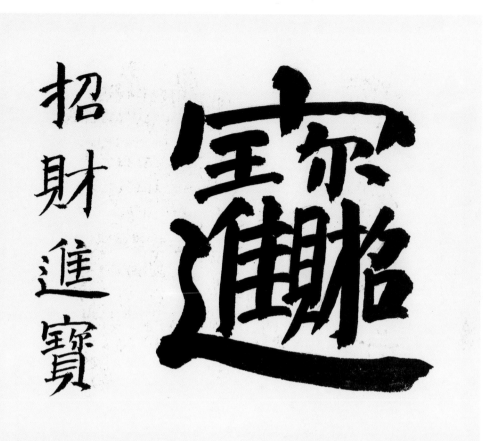

8 *Zhao cai jin bao* (Bringing in wealth and riches) rendered as in folk art.

flipped, customary modes of thought are thrown into confusion, creating obstacles to connections and expression. It is by opening up these unopened spaces that we may revisit the origins of thought and comprehension.

Art has value because it is genuine, not false. If you create art, the material "you" will mercilessly reveal you in all your complexity. Perhaps in life you can hide, but in art it is impossible. Regardless of whether you hope to hide or to flaunt an idea, it will all be recorded. That which belongs to you is yours. You may wish to get rid of it, but you cannot. Then there are those things that do not belong to you and, regardless of your effort, will never belong to you. All of this is decided by fate. This might sound fatalistic, but it is what I have experienced. In reality, this "fate" is what you experience: it is your cultural background and your life. It determines the inclination and style of your art. Your background is not of your own choosing; this is especially true for mainland Chinese artists. As far as I am concerned, artistic style and taste are not manmade; they are heaven-sent.

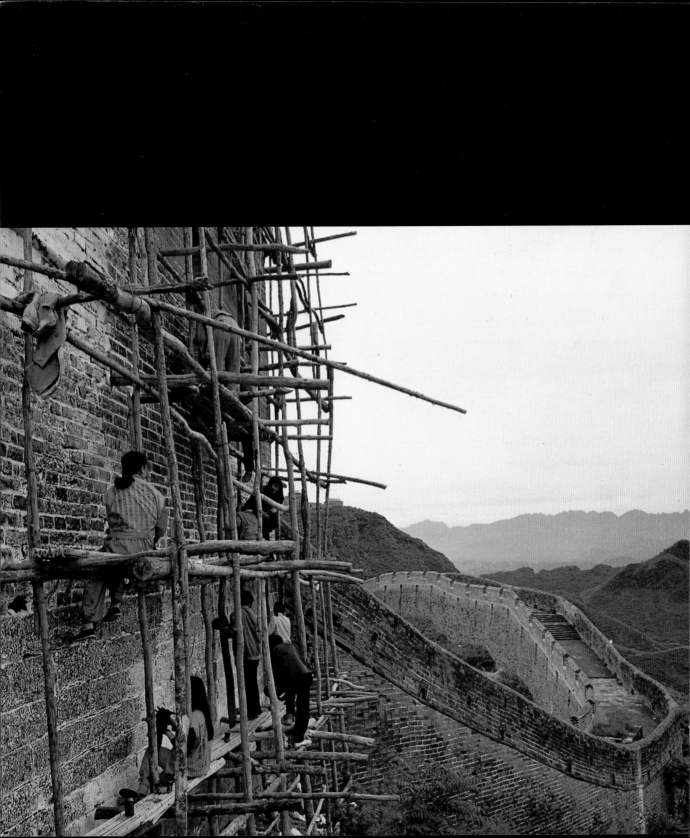

eARLY in his career, Xu Bing established a pattern of quietly undermining accepted paradigms. His earliest innovations fell within the context of an art world under government control, where even the notion of change could have political ramifications. Single-mindedly pursuing his own vision, Xu Bing reintroduced apolitical subject matter into woodcuts, reformed the way drawing is taught, upset notions of what a print can and cannot be, and created some of the first Chinese installation art—all prior to or during 1987, the year he earned his master of fine arts degree. To overturn the status quo was not necessarily his intention, but he instinctively operates outside the norms of his given situation: he is a natural iconoclast. At times Xu Bing's fresh point of view has struck a deep chord, with profound consequences for the course of Chinese art and, perhaps ultimately, for contemporary art in general (fig. 9).

ONE

The Quiet Iconoclast

In 1968 Chairman Mao announced that urban youth were to be sent to the countryside for re-education. He declared, "It is very necessary for educated youths to go to the countryside and learn from poor and lower-middle-class peasants. We must persuade urban cadres and others to send their sons and daughters to the countryside after they graduate from junior high and university, to bring about a mobilization. All comrades in the villages should welcome them."[1] Through directly experiencing peasant life, high school and university students were to reform their value systems and ultimately arrive at a better appreciation of the peasant's role as the foundation of Chinese society. They were supposed to realize that agricultural labor was more essential than intellectual labor, and therefore morally superior. Mao's motives were not purely idealistic: this was a way of removing possible troublemakers from the overcrowded cities, made restless in part by economic shortages.

By 1972 the government had sent four hundred thousand people to the countryside for re-education. Xu Bing joined their numbers in 1974, having graduated from upper middle school (high school) the previous year. With four other students he shared a household in Huapen Commune, a village of just thirty-nine households that farmed poor land in Yanqing District northwest of Beijing (fig. 10). The students' primary responsibility was to work alongside the peasants in the fields. As Xu Bing relates, "Every day when we finished our work [in the communal fields], we would then go take care of our personal plot of land. After dark we would return home, cook our meal, and still have to tend to the pig and chickens. In the evening we liked to drop in on the commune members at their homes."[2]

10 Xu Bing at Huapen Commune, 1975–76. Photograph courtesy of and reproduced with permission of an anonymous individual.

While some educated youth became bitter about their forced move to the countryside, others, including Xu Bing, found a positive side to the experience. Although it was a difficult time, for him it was a finite period, and he was grateful for the opportunity to leave Beijing. At Beijing University his family had been persecuted for belonging to the despised bourgeois liberal class. His father, who had been chair of the history department at Beijing University, was sent to prison to be "reformed" through labor, and Red Guards harassed the remaining family members. Things were different in the countryside. There, the peasants did not care about Xu Bing's bad class background. They judged a person in more tangible terms, such as how hard someone worked in the fields. Furthermore, Xu Bing appreciated the beauty of his surroundings and enjoyed the predictable rhythm of agricultural life.

As a means of putting their intellectual skills to service, the students in Huapen Commune produced the illustrated newsletter *Lanman shanhua*, selecting for the title a line of Mao's poetry: "Brightly colored mountain flowers in full bloom." Each issue included poems, songs, and essays by local people, with illustrations and elaborately inscribed titles by Xu Bing (fig. 11). His small drawings of aspects of village life peppered the newsletter, lending it such panache that its popularity spread beyond Huapen to the surrounding villages. Copies made their way back to Beijing, where Liu Chunhua (born 1944), the head of the Beijing Culture Bureau, saw them. Liu Chunhua made a special trip to the village to learn more about the newsletter and to see Xu Bing's carefully written chalkboards.[3]

Due to his talent and dedication, Xu Bing was recommended for admission to the May Seventh College of Arts in Beijing, a Cultural Revolution institution created by Mao's wife Jiang Qing (1914–1992) and incorporating the former Central Academy of Fine Arts. Xu Bing was admitted as a peasant. Only members of the worker-peasant-soldier class qualified, and he had been identified as an art worker in Huapen.

With Mao's death in September 1976, the Cultural Revolution came to an end

and, as part of the subsequent reorganization of the educational system, the May Seventh College of Arts was broken apart. When he returned to Beijing from Huapen in 1977 to embark upon his formal art training, Xu Bing found himself in the newly reinstated Central Academy of Fine Arts. He had hoped to study in the oil painting department, but he was directed instead to the print department. Since the 1930s the Chinese Communist movement had promoted printmaking, and especially woodcut, as a valuable, nonelitist medium. Printmaking was deemed nonelitist both because it produces multiple images that enable broad distribution and because it communicates on a direct emotional level, one more widely understandable than, for example, traditional paintings made by scholars with brush and ink. In the long run, Xu Bing's position in the print department has proven beneficial. Technically, the different forms of printmaking he studied, such as woodcut, engraving, and mezzotint, prepared him to work with the wide variety of materials he has employed in his later career as a multimedia installation artist.

11 First *Lanman shanhua* newsletter, no. 1, 1975. Paper, 26.7 x 19.4 cm.

Xu Bing's most important project from his early years at the Central Academy is the series of over one hundred twenty *Small Prints* made from 1978 to 1983. Most of the images are smaller than fifteen centimeters (or six inches) square, and for a time Xu Bing produced one a day. Each woodcut depicts an aspect of life in the countryside, ranging from farmyards (fig. 12) and village streets to snow-topped haystacks and piles of pumpkins. In style and spirit they are the descendants of the small illustrations he made for the *Lanman shanhua* newsletter, but they are more carefully rendered and stripped of any overt political content. On a return visit to Huapen Commune, Xu Bing brought along his *Small Prints* of village life. The peasants admired them, with one remarking, "You take a fresh look at this rundown place of ours—the way you portray it, it's really lovely!"[4] Although Xu Bing had not prettified rural life, he had represented it from a warm and personal point of view.

At that time, this was a radical approach. Several decades earlier, the woodcut artist Gu Yuan (1919–1996) had created images of the simple rural life, and his illustrations of local farmers were inserted in the Yanan *Liberation Daily* (1943).[5] With the

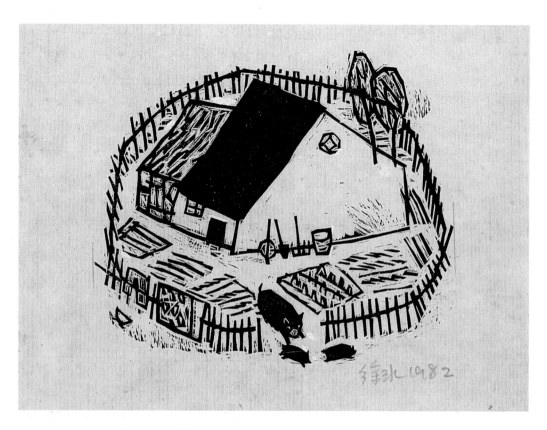

12 *Small Prints: Farmyard*, 1982.
Woodcut on paper, 12 x 14 cm.

hysterical hyperbole of the 1960s and 1970s, however, such under-
stated images became decidedly *outré*. Xu Bing admired and later
studied with Gu Yuan. Perhaps Gu Yuan was a source of inspiration
for the *Small Prints,* but their simplicity and intimacy far exceed that of Gu Yuan's
work.

Ever since Mao delivered his "Talks at the Yanan Forum on Literature and Art" in
1942, Chinese Communist Party policy had dictated that art should serve the people.
As peasants made up the vast majority of the people in China, this meant that much
of art must serve their needs. The interpretation of this policy varied, but Cultural
Revolution art frequently idyllicized rural life by depicting the countryside as being
populated with rosy-cheeked peasants who were happily engaged in backbreaking
labor or were posing with the unrealistically abundant harvests that their super
human efforts yielded. Other representations of peasants served a more didactic pur-
pose, encouraging them to learn to read or urging them to study the "Little Red Book"
filled with Chairman Mao's quotations. Artists who did not heed Maoist policy and
instead created "art for art's sake" were labeled bourgeois liberals and were severely
punished.

In the context of the government's long-term control of art for its own purposes,
Xu Bing's *Small Prints* appeared as a truly remarkable breath of fresh air. These small
works of art bore no didactic message, nor did they actively promote attitudes or

policies supported by the government. Perhaps their warm view of peasant life saved them from being relegated to the despised category of bourgeois liberal art. The prints captivated the imagination of those weary of propagandistic art. For them, the prints hinted at new avenues of artistic creation. When the prints were published as a small book in 1986, their influence inevitably spread.

Xu Bing began his career as an iconoclast, albeit a quiet one. In China during the 1970s and early 1980s, to be an obvious iconoclast broadcasting his intentions to the world would have been dangerous. That was not, however, Xu Bing's primary motivation for forging his own path without drawing undo attention to himself. More than just a practical survival strategy, being a quiet iconoclast is part of his everyday existence. Xu Bing's ability to negotiate his position in complex situations may derive from his childhood. As the middle child with two older and two younger siblings, he early on learned how to follow his personal inclinations without making waves. Always he is persuasive rather than confrontational.

In 1987, Xu Bing earned his master of fine arts degree from the Central Academy. For several reasons, the Central Academy then hired Xu Bing as one of the youngest artists ever to teach there. He demonstrated superb technical facility with a variety of print media. His *Small Prints* showed a viable new direction for Chinese art, and his sketch of a plaster cast of *David* by Michelangelo Buonarroti (1475–1564), done for a first-year drawing class in 1977, set a new standard for excellence in drawing (see fig. 1). As an instructor, Xu Bing brought a fresh approach to both drawing and printmaking. He explored the limits of the medium with his print students. Their exhibition of a print they had taken from a giant truck tire generated great interest.[6] Instead of requiring the students in his drawing course to produce rapid sketches from nude models or from plaster casts of Western classical sculptures—the norm in Chinese art academies—Xu Bing prepared bundles of found objects and encouraged his students to create one finished drawing over an extended period of time.[7] His own acclaimed drawing of *Michelangelo's David* had taken him five weeks to complete.

The issue of how to draw was not as simple as it might first appear, and the proper approach to drawing instruction was a hotly debated topic in the later 1980s. The imported Soviet scheme prescribed a regularized course of instruction that would ensure all artists were capable of rendering the same object or scene in the same manner.[8] Ultimately, this resulted in a uniformity of expression among socialist realist works of art. In figure drawing, students first learned how to draw a head, then a bust, a torso, a figure, and a pair of figures. With still lifes, students followed the same pattern of gradually building isolated elements into large compositions, starting with an apple, for example, then two pieces of fruit, a complete composition of

13 Feng Mengbo. Detail, *Untitled*,
1987. Pencil on paper. Now
destroyed. Reproduced with
permission of Feng Mengbo.

fruit bowl with bottles, and so on. Emphasis was placed on training students to be able to reproduce the appearance of a wide range of things. A second politically acceptable form of drawing was the fast sketch. Artists quickly noted what they saw when visiting farms and factories, and these rapid sketches enabled them to remember their experiences when they were close to the people. In both cases, drawing was used as a tool in preparation for a later work of art and as a way to record the appearance of things.

Xu Bing believed that through drawing, an artist could learn about the relationship among himself, his process of looking, and the object observed. As a teacher, however, Xu Bing knew that if he presented his drawing students with a live model or a plaster cast, they inevitably would approach the drawing exercise in the usual manner, conceiving the image in terms of an accumulation of parts: head, bust, torso, etc. To disrupt the students' usual mode of thinking, Xu Bing provided them with unorthodox subjects, for example, a plaster cast of a classical frieze partially wrapped with newspaper tied on with string, or an old bicycle, or an upturned tree root wrapped with rope. This method of teaching was similar to that of a Chan master who presents his student with a koan so as to disengage usual thinking patterns. Since Xu Bing's still lifes could not be broken down into familiar units, such as face, torso, or piece of fruit, his students were forced to consider the whole and discover a new approach that would work for them. With unusual subject matter and a fresh approach, there was more opportunity to locate and develop personal strengths and interests.

In 1987, during his first semester at the Central Academy, Feng Mengbo (born 1966), now China's leading computer artist, participated in Xu Bing's experimental drawing class. There he completed a drawing of the wrapped tree root (fig. 13). In describing this liberating experience, he noted the innovations it catalyzed for him.

> When I made the drawing, I used some technology which other students had never tried: to give the picture a very strong feeling of being [tautly] bundled, I used a ruler and sharp pencil to draw the cable, which really surprised the others. I discovered it's very natural—to do an artwork, I can use any material that I can find. Also, I used a strange

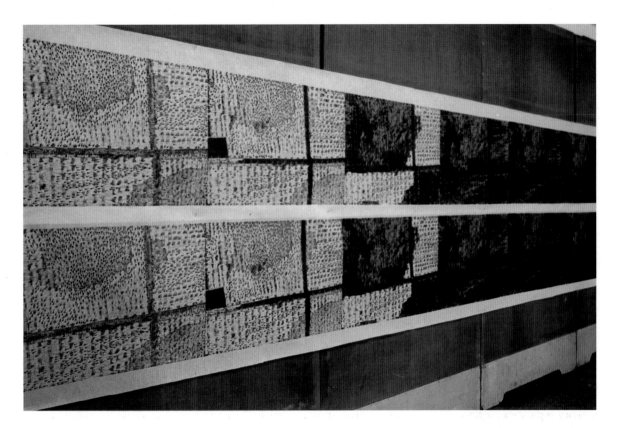

style to draw the tree branch, and gave it a very plain background. Anyway, I made the drawing not only a classwork—what I wanted was to make a work of art, and I got it. That's my first grade in the college, and I was lucky to meet a good teacher.[9]

14 *Five Series of Repetitions,* 1987.
Woodcut on paper, 45.7 x 533.4 cm.

Cai Jin (born 1965), another of China's premier artists, ranks drawing as an art of equal importance to oil painting and installation art because of her experience in Xu Bing's class. Studying drawing with him spurred her development of a distinctive personal style characterized by the use of very fine mechanical pencils and the expenditure of days or weeks on a single small drawing. Subsequent drawing teachers have adopted Xu Bing's way of teaching this branch of fine arts, and the "Xu Bing method" is still discussed at art education meetings.

Xu Bing pursued new approaches to printmaking, too, first by incorporating the process of making prints as a subject in his works, and second by pushing the limits of the medium. The 1986–87 woodcuts titled *Five Series of Repetitions* (fig. 14), for example, record the stages of carving the block of wood prior to printing, a process that is usually obliterated. For these works, he made an impression of each stage—beginning with a solid black print from an uncarved block and ending with a blank white "print" representing the block after the raised surface had been completely carved away—and then mounted the prints successively in a strip. Progressing from nothing to something and back to nothing, they hint at the cycle of life. In symbiosis with this

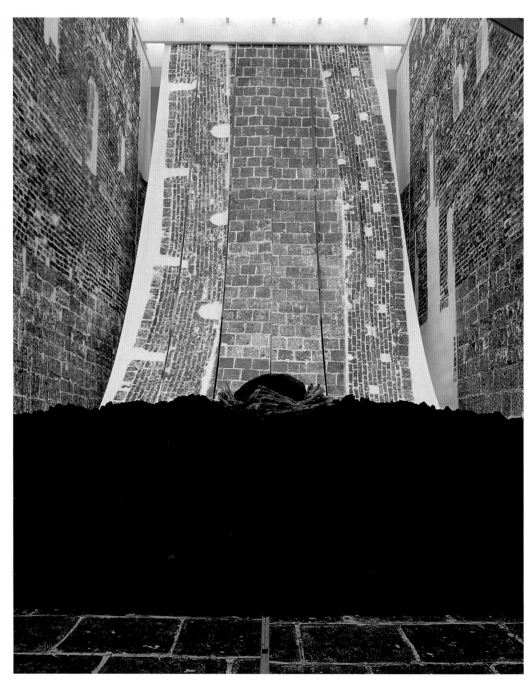

15 *Ghosts Pounding the Wall*, 1990–91.
Rubbing on paper. Installation view
from the exhibition *Three
Installations by Xu Bing* at the
Elvehjem Museum of Art, University
of Wisconsin-Madison, November 20,
1991, to January 19, 1992. Photograph
by Greg Anderson. Photograph
courtesy of and reproduced with
permission of Elvehjem Museum of
Art, University of Wisconsin-Madison.

notion, the subject matter is fields and ponds that gradually fill
with life, only to be then emptied of it.

In 1986, when Xu Bing and his students made the *Big
Wheel,* a print of giant truck tire treads, they were driving home
the point that a print can be taken from almost any solid sur-
face. During the mid-1980s, installation art was just beginning
to appear in China. The exhibition of the tire itself along with
the print marked one of the first examples of installation art in
Beijing. The following year Xu Bing created *Run of Alignment of*

the Great Wall, a rubbing taken from the Great Wall. Rubbings are a traditional Chinese method of printmaking, used exclusively to reproduce historical images and exemplary writing. Never before had anyone thought to make a rubbing from such an unrefined surface as the massive blocks that make up the Great Wall. Although innovative in itself, *Run of Alignment* proved to be just the trial run for the grandiose *Ghosts Pounding the Wall* (fig. 15), doubtless the largest print ever made and certainly Xu Bing's most extreme effort to investigate the limits of printing.

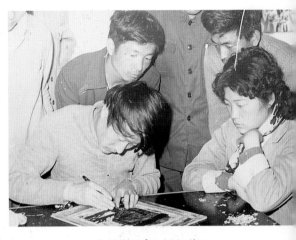

16 Xu Bing demonstrating woodcut technique at the Qiu Oilfield workers' art department, 1982. Photographer unknown.

In May and June of 1990, Xu Bing and a team of art students and peasants spent more than three weeks taking a rubbing from the Great Wall at Jinshanling. The team members used temporary glue to adhere sheets of rice paper carefully to the wall, then they patted pads moistened with ink over the paper to obtain an impression of the wall's surface. Although the materials and technique Xu Bing used are traditional, the scale of this rubbing is absolutely unprecedented, being a full-sized impression of a portion of the walkway on top of the wall and of two sides of a tower. The artists labored on the wall from dawn until dusk, resting only for lunch, and still Xu Bing found it necessary to increase the number of people who were helping him by enlisting eight local peasants. The expanded team finished the rubbing after twenty-four days of perching precariously atop wooden scaffolding erected next to the tower (see fig. 9). As an indication of the project's size, it consumed approximately three hundred bottles of ink and thirteen hundred sheets of paper. Having completed the rubbings, Xu Bing moved to the United States, where he mounted and assembled them as the installation *Ghosts Pounding the Wall.* Again, the scale of the project was daunting. At times assisted by a professional mounter but working mostly unaided, he spent four months in a warehouse mounting the forty-five hundred square feet of rubbings.

Until Xu Bing left China to live in the United States, government policies constrained his career to varying degrees. The Chinese government supported all art academies, art schools, publishing houses, and artists' organizations, and opportunities to sell works of art to collectors or through commercial galleries were extremely limited until the early 1990s. It thus was next to impossible to survive as a full-time artist without holding a government-funded position. Xu Bing skillfully negotiated this system, simultaneously managing to conform to Communist Party art policies-desiderata while opening new artistic territory. From 1974 to 1977 he threw himself

into the idealistic spirit of Mao's educated youth rustication program, and he produced the newsletter *Lanman shanhua*. While a student at the Central Academy from 1977 to 1981, and later as a teacher, he volunteered repeatedly to be sent to work with the people. He spent time in villages and industrial sites sketching, learning from folk artists, and teaching introductory printing classes (fig. 16). During this time he produced the bulk of the *Small Prints* and won a first prize in the 1978 student exhibition

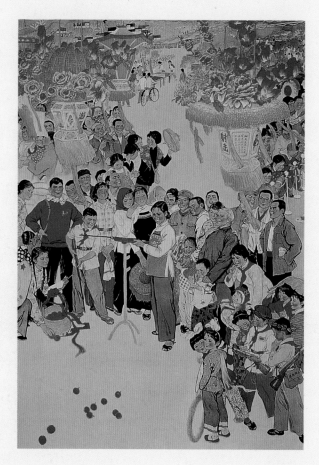

Despite Mao's pronouncements that art should be made for the people—by which he meant workers, peasants, and soldiers—and express a deep understanding of their lives, during the Cultural Revolution images of rural life generally strayed far from reality. In the 1950s China had imported and promoted the socialist realist style of painting from the Soviet Union. Socialist realism presents idealized views of the world as it theoretically should appear in a fully realized socialist state. Such a realm can contain only heinous villains and right-thinking protagonists: there is no

17 Anonymous. *Gongshe de jieri* (Holiday in the Commune), early 1970s. Poster, 76.8 x 53 cm.; size of image only: 69.5 x 48.9 cm. People's Art Press, Beijing, no. 86–680. Anonymous collection.

at the Central Academy. As a teacher at the Central Academy from 1981 to 1984, he was not adversely affected by the Anti-Spiritual Pollution Movement (1982–83) through which Deng Xiaoping (1905–1997) attacked various innovations in the arts, since his art did not involve controversial media or subject matter. Xu Bing was allowed to exhibit his work overseas (France and Sweden in 1982, Iraq and Germany in 1983, etc.), and his work was published in 1986 on the "Art Page" of *Beijing Review* (a foreign-language government publication for overseas consumption), testimony to his position as an artistically exemplary, politically innocuous representative of China. In 1985 he was even made a director of the conservative Chinese Artists'

Association. By the time he earned his master's degree from the Central Academy in 1987, Xu Bing had been an innovative force within the boundaries of the Chinese art establishment for over a decade, uniformly receiving approbation rather than derogation. It was only after his best-known work, the *Book from the Sky*, was severely criticized—compounded by the massacres in Tiananmen Square on June 4, 1989—that the constraints on his artistic creativity came to seem intolerable. He moved to the

gray in-between area. If peasants apply socialist principles to farming, again there can be no gray area. The result should only be bumper harvests and clean, well-ordered villages filled with happy, healthy commune members. Artists of the Cultural Revolution period produced numerous images of utopian agricultural society, some of which were reproduced as posters and printed in editions of tens and even hundreds of thousands.

Holiday in the Commune (fig. 17), published in Beijing in the early 1970s, is typical of the kind of poster that was produced for popular consumption during the period when Xu Bing dwelt in Huapen Commune. The peasants, all of them strong, healthy, and scrubbed until rosy-cheeked, wear new clothes in a variety of bright colors and patterns. In the foreground a young woman and a boy test their marksmanship, while behind them children angle for toy fish and others play Ping-Pong. Tucked in the background to convey the commune's wealth are a shiny new tractor and a row of bicycles. Elaborate lanterns, mysteriously suspended and bedecked with flowers, highlight the fact that this prosperous village has much to celebrate on National Day. A banner overhead exhorts everyone to apply proletarian thinking in the village, and a straw hat bears the inscription, "In agriculture, study Dazhai" (a model commune). Workers and soldiers visit the commune for the celebration, and various ages and minority peoples are represented, indicating that in the socialist utopia everyone lives in harmony and comfort.

While such posters bore witness to the theoretical wonders wrought by the application of Mao Zedong thought to agriculture, in reality farming remained an arduous life of poverty.

United States in 1990. Now working in the West, Xu Bing quietly undermines the current paradigms of Western art practice and yet is highly successful within that system, once again practicing the modus operandi he developed in China.

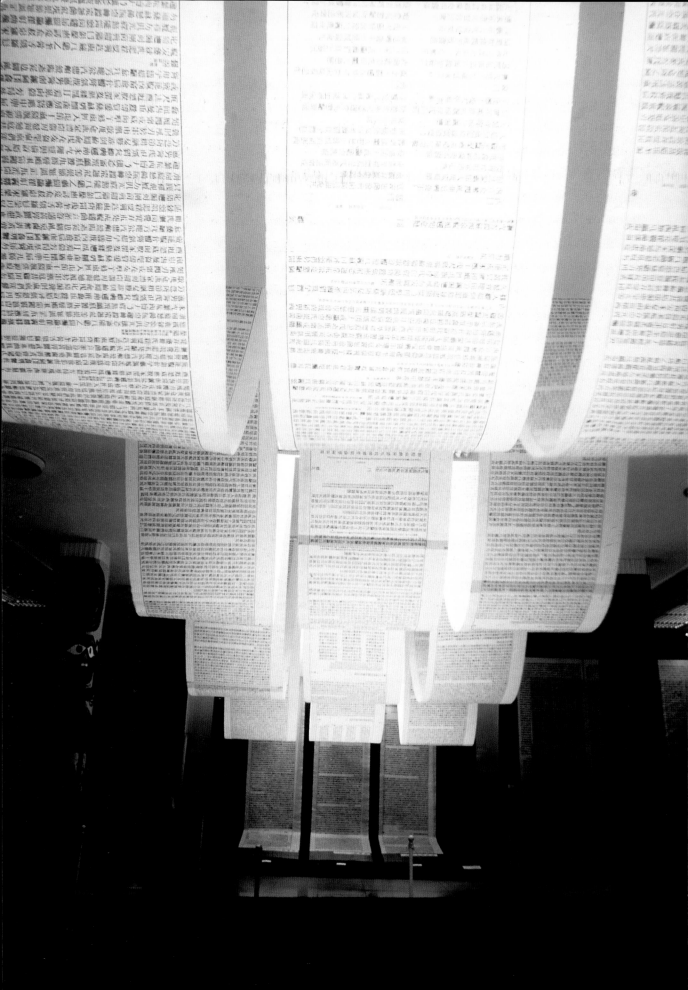

QUITE likely more has been written about the *Book from the Sky* than any other work of art by Xu Bing (fig. 18). Since its sensational debut in Beijing in 1988, it has incited continuous intellectual debate, first within China and now throughout the international arena. The work's tantalizingly elusive meaning fuels the debate, provoking both scholars and students of art to pull out all their methodological tools as they seek to plumb its depths. We can turn to the giants—Barthes, Derrida, Foucault—but nothing quite does the trick.[10] As Xu Bing has noted, it is because he says so little about the *Book from the Sky* that others say so much.

The *Book from the Sky* is a set of four books printed with more than a thousand different characters that Xu Bing invented but are devoid of any real meaning (fig. 19). The title also refers to an installation in which the book sets are combined with scrolls draping from the ceiling and huge wall panels that are also printed with the artist's unintelligible characters (fig. 20). Prior to the *Book from the Sky*, Xu Bing produced etchings that

Mistrust of Language and the *Book from the Sky*

likened modern detritus (a battered tin cup) to prehistorical traces (that is, fossils, themselves a kind of print), and he created prints made from unusual surfaces, such as a truck tire or the Great Wall. These works suggest a mind at work, probing for new directions. Even so, a huge conceptual leap was required to get from there to the *Book from the Sky*, a profound major work focusing on language. How did Xu Bing come to devote several years of his life to creating sets of unintelligible characters? The answer is complex, for Xu Bing's convoluted interest in language has been influenced at many stages of his life.

Xu Bing's fascination with language and books began before he could read or write, due largely to his mother's long-term affiliation with Beijing University's department of library sciences, where she was senior administrator. Through her association with the university, and that of his father, who was chair of the history department, Xu Bing developed a fondness for historical books at an early age. He remembers that he often accompanied his mother to work, where he enjoyed passing the time surrounded by books. At about the time Xu Bing was old enough to learn to read, the government reformed the language by simplifying characters in an effort to make widespread literacy an obtainable goal. For Xu Bing, however, language began to seem unreliable. He became fascinated with the form of language rather than the content, and in 1969 and 1970 he assembled a collection of newspaper fonts when he

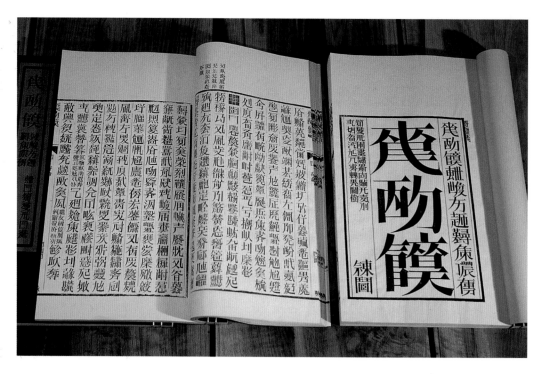

18 page 32, *Book from the Sky.* Installation view of the exhibition at the China Art Gallery, Beijing, 1988.

19 above, *Book from the Sky.* Pages from two of the set of four books, 1987–91.

was in middle school. He thought that one day he would write a "handbook of artistic lettering," based on his methodically organized collection.

During the Cultural Revolution, almost all written language served a political purpose, from the widely distributed "Little Red Book" of Chairman Mao's thoughts and the publicly displayed big character posters proclaiming the latest political slogans, to the privately written "confessions" of political undesirables. One of Xu Bing's most vivid early memories relates to a devastating big character poster.

> I went to see the big character posters.... I looked and looked, and all I could see was "Down with Xu Huamin."... When [a crowd of people surging down the street] got to where I could see, the first person in custody was Xu Huamin, my father. At that time I absolutely did not dare to look at him. I just remember seeing his shoes half dragged along the ground as his captors pulled him—those shoes left a very strong impression on me, as I had often seen them at the end of my father's bed. I remember acting at the time as if nothing was happening; the student I was with had no idea that was my father. ... Later by chance I saw my father on the grounds of Beijing University: a team of reactionaries was there doing some weeding.[11]

Like many other children from Beijing University with "reactionary" parents, Xu Bing strove to prove himself as a revolutionary. His calligraphy was so good that he began to write political posters. (Ironically, his father had taught him calligraphy.) The Beijing University middle school did not have an art teacher, and thus it came to rely

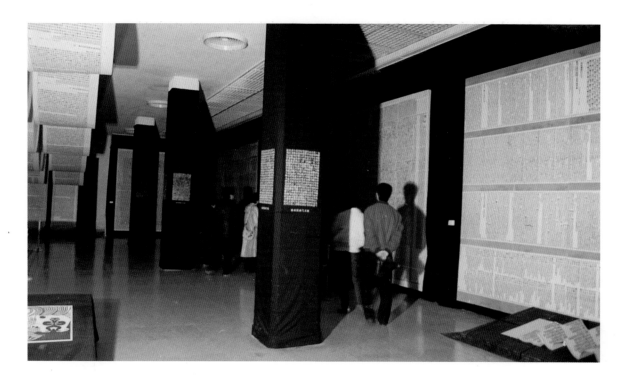

upon Xu Bing for most of the school's propaganda writing, ranging from big character posters to blackboards for classroom discussions and criticism meetings. Often he worked at this task until long after midnight, employing the decorative newspaper fonts he had collected. Eventually he developed bleeding ulcers from all the stress. Upon graduation from middle school, Xu Bing went to live in Huapen Commune, where he put his knowledge of decorative fonts to use in the service of the *Lanman shanhua* newsletter that he and other intellectual youth produced for the villagers. When he began his formal training as an artist, however, language and books did not translate immediately into a subject for his art.

20 *Book from the Sky*. Installation view of the exhibition held at the China Art Gallery, Beijing, 1988.

With Mao's death in 1976, the decade of the Cultural Revolution came to an end. The level of propaganda dropped off and, during the 1980s, communication with the West gradually increased. Circles of artists and intellectuals eagerly devoured the Western philosophical and art historical texts that began to arrive and, even better, to be translated. For many people the pastime of reading Western texts and participating in related discussion groups became an all-consuming activity by mid-decade. Like everyone else, Xu Bing was enthralled by the writings of Nietzsche, Wittgenstein, Camus, and others, but he was also reading Chan texts and exploring the Beijing University's library stacks, where he focused on historical books and rubbings.

Eventually becoming wary of such passion for words—the content of words, not the form—Xu Bing detached himself from this activity. He recognized that the Cultural Revolution had been fueled by words and that now, with the import of

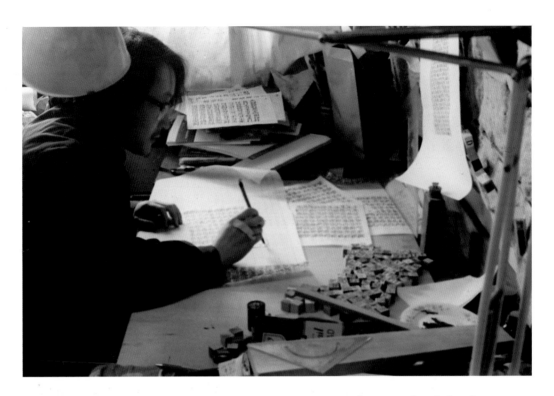

Western texts, words were again consuming young minds. He realized that he was doubly consumed by words, given his interest in historical books. As he relates, "The more I read, the more muddled my thinking became, until I felt as if something had become lost to me. I was like a starving person who all at once has too much to eat and winds up so uncomfortable that he is filled with disgust."[12] This propelled Xu

Bing's conception of the *Book from the Sky*. By 1986 he was experimenting with a handwritten version. Then, beginning in 1987, he closeted himself in his dormitory room-studio at the Central Academy, where he devoted a year to creating the first printed version of the *Book from the Sky*. Highly methodical, he systematically recombined elements drawn from genuine Chinese characters, with the aim of inventing new characters devoid of meaning (fig. 21). Most of the invented characters he discarded as looking unnatural or not being sufficiently aesthetically pleasing. Nevertheless, he finished the project with approximately twelve hundred fifty invented characters. He then carved each one into two sizes of small wooden blocks suitable for typesetting and printed several forms of books, scrolls, and wall panels. These he produced himself without the aid of professional bookbinders. After exhibiting them in 1988, he decided to make a new and better set. He had enjoyed the repetitive, meditative process of designing and carving the characters, and the withdrawal from public life was reminiscent of historical Chinese scholars who were perturbed with society. The second time he carved one thousand large and one thousand small characters, and he worked with a small factory in Daxing to print and bind the sets of four books (fig. 22). These are the books that Xu Bing has exhibited as the *Book from the Sky* since 1991.[13] This set adheres, with even greater fidelity than the first, to the format and methods of the traditional Chinese book arts. The fact that Xu Bing felt compelled to produce a second, improved version of this already extremely demanding project is testimony to his belief—often stressed to his students—that an artist must see a work of art through to the end, with no room for compromise.

In October 1988, Xu Bing exhibited the *Book from the Sky* for the first time, in his solo exhibition at Beijing's China Art Gallery. The *Book from the Sky* installation consisted of open books displayed on low platforms, panels of text mounted on pillars and walls, and three long scrolls that ran up the wall and then draped in swooping arcs down from the ceiling (fig. 23). Immediately, the installation caused a grand, unprecedented commotion in the art world. Several widespread reactions characterized the turmoil. First, people were reluctant to believe that the text of this enormous undertaking was completely unintelligible. The invented "characters" so closely resemble genuine characters that some people reportedly spent days searching for one they could read (fig. 24). In fact, since the exhibition, *Book from the Sky* aficionados have discovered several authentic characters—most of them extremely arcane—that Xu Bing inadvertently reinvented.[14] As a second general reaction, visitors to the exhibition were aghast at the notion that someone would devote so much time and energy to creating an unreadable text. Third, on a more profound level,

21 Xu Bing designing the characters for the *Book from the Sky*

22 Working on the *Book from the Sky*, Caiyuxiang Ancient Books Book Factory in Daxing.

many people expressed an overwhelming emotional reaction, combining feelings of sadness, oppression, and wonder.

Xu Bing intended the *Book from the Sky* to evoke such feelings. He originally titled the work *An Analyzed Reflection of the World—The Final Volume of the Century* (Xi shi jian—shiji mo juan), which can also be translated as *The Mirror of the World—An Analyzed Reflection of the End of This Century*. He sometimes explained the title's meaning in simpler language as the "book that analyzes the world" *(Fenxi shijie de shu).*[15] Bound up in these titles is a sense of general pessimism regarding Chinese culture coming to a cataclysmic head as the end of the century—or of the world—approached. The installation seemed to suggest that the weight of millennia of Chinese culture oppressed

23 *Book from the Sky.* Installation view of the exhibition at the China Art Gallery, Beijing, 1988.

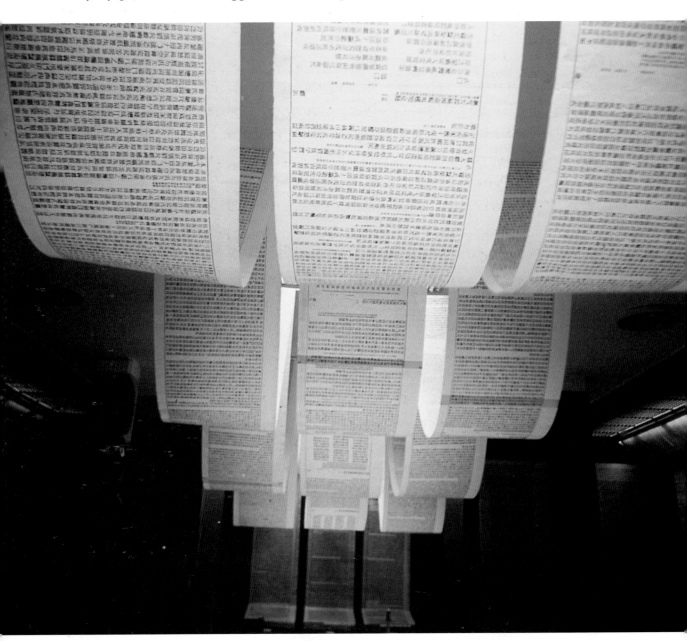

those living at the end of the twentieth century who were searching desperately for answers but finding few. Visitors to the exhibition remarked that they felt as if they were in a prison, completely hemmed in by unintelligible words. In particular, the scrolls draped from the ceiling seemed to press down on them. For other visitors, the exhibition evoked sensations similar to those felt in a temple or in a hall of mourning. Some people felt breathless or frightened. Still others found themselves overwhelmed with a more positive experience, as the installation inspired them to marvel at the length and wonder of Chinese civilization.

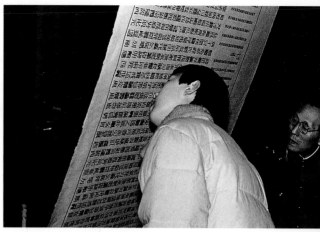

24 Puzzled visitors viewing the *Book from the Sky*, China Art Gallery, Beijing, 1988.

Not long after the work was shown to the public, a new title, the *Book from the Sky* (Tianshu), was coined. The *Book from the Sky* (also translated as the *Book from Heaven*) seemed an apt title because the scrolls draping down from above had made such an extraordinary impression and because *Tianshu* denotes unintelligible text sent down from heaven. Xu Bing acquiesced as it came into general usage.

Ironically, considering what the work of art says about the value of language, Central Academy scholars held a formal discussion of the *Book from the Sky* and its implications in October 1988. Artists, art theorists, and scholars at the Central Academy and elsewhere met to debate the *Book from the Sky* phenomenon, and enormous quantities of ink were spilled as artists and critics attempted to come to terms with this sensational installation. At a time when Chinese art was in a critical phase of development, Xu Bing's installation offered hope for the future. Throughout the 1970s and early 1980s, avant-garde artists had experimented with numerous approaches to art, culling them largely from the recently imported texts that had brought them new but very belated awareness of twentieth-century Western art movements. Impressionism, expressionism, surrealism, dada, abstraction, photorealism, performance, installation: the whole gamut of Western art trends paraded through post–Cultural Revolution China with very mixed success. More talented artists found inspiration to create something new and relevant to their lives; the rest became bogged down in empty copying. This was a worry, to say the least. When the *Book from the Sky* appeared, it proved that Chinese art could make a major contribution to international art without needing to apologize for its indebtedness to the West. While the format (i.e., installation) had come to Xu Bing from the West,

everything else about the *Book from the Sky* was undeniably Chinese. Xu Bing, of course, knew that repetition was a tool in the art of Andy Warhol (1928–1987), but the repetition deployed in the *Book from the Sky* was not a Warholesque reflection of industrialization: it came directly from traditional Chinese book arts.

In February 1989, *China/Avant-Garde,* a long-awaited exhibition of the '85 New Wave art movement (i.e., avant-garde art from about 1985 on), opened at the China Art Gallery in Beijing. Curated by Gao Minglu (born 1949) and Li Xianting (born 1949), this was the first group show of avant-garde art exhibited in a major Chinese gallery, and it displayed the *Book from the Sky* as a centerpiece. A heady sense of optimism pervaded as China's young artists found themselves in an officially sanctioned exhibition in the nation's most prestigious art gallery. No doubt the future would offer more opportunities.

Unfortunately, such hopefulness was ill-founded. During the first day of the exhibition, the Beijing Public Security Bureau (the police) found fault with several works of art and arrested one artist for selling shrimp. When a performance artist produced a gun and fired a blank at her partner's work of art, the two were arrested, and the exhibition was temporarily closed. Finally, after two weeks, authorities closed the exhibition permanently due to bomb threats sent to the gallery and other government bodies. The Ministry of Culture ordained that all subsequent public art exhibitions must have the works of art pre-approved. Li Xianting and Gao Minglu were prohibited from organizing exhibitions for two years, and the journal that had supported the New Wave art movement, *Fine Arts in China* (Zhongguo meishu bao), was required to close down for two years. (It has not recommenced publication.) Thus ended the period of optimism.

In the spring of that year, many artists supported the blossoming democracy movement by demonstrating, producing posters, or contributing money or labor to the creation of the *Goddess of Democracy* statue. When People's Liberation Army troops slaughtered peaceful demonstrators in Tiananmen Square on June 4, 1989, no hope was left. Having brutally quelled the democracy movement, the government embarked on major campaigns to discourage further insurrection. By August the censorship campaign had resulted in government confiscation of twelve million books, magazines, and videotapes. This action was referred to as "cleaning out the 'cultural garbage.'"[16]

Seeking a whipping boy within the avant-garde art milieu, the government settled on Xu Bing and his *Book from the Sky,* which artists and critics had widely and publicly ordained as the definitive work of the New Wave.[17] The *Literature and Art Newspaper* (Wenyi bao) published a lengthy diatribe against the New Wave

movement written by Yang Chengyin (dates unknown), a Central Academy professor. He began by outlining the evils of the movement. The New Wave of Fine Arts, he said, was a "trend counter to the Communist Party's artistic direction and policies" and was detrimental to the development of "socialist spiritual civilization." About a third of the way into the essay, Yang Chengyin progressed to vilifying Xu Bing's *Book from the Sky* as encapsulating all the negative qualities of the movement in general. He made it plain that he had singled out the *Book from the Sky* because many critics considered that piece to be the most representative work of the New Wave.

> I have always felt that when people do something, they cannot follow their subjective desires alone without taking objective laws into consideration. I have always felt that when people do something they must have a clear goal, for themselves, for others, for the people, for all mankind—to have no purpose at all is absurd and dissolute. If I am asked to evaluate the *Book from the Sky*, I can only say that it gathers together the formalistic, abstract, subjective, irrational, anti-art, anti-traditional . . . qualities of the Chinese New Wave of Fine Arts, and pushes the New Wave towards a ridiculous impasse. I am reminded of a Chinese idiom, "ghosts pounding the wall." In the past, a traveler was walking in the midst of a dark night. When he lost his sense of direction and lost all reference points upon which he could rely to judge where he was, he spent the rest of the night walking in circles in the same spot. It was as if a ghost had built an invisible wall, making it impossible for [the traveler] to leave its confines. Can't we say that [the *Book from the Sky*] as well as the above mentioned non-expressive art is the phenomenon of "ghosts pounding the wall" in human thinking, activity, and artistic creativity? . . .
>
> The essence of the Chinese New Wave of Fine Arts is to oppose the laws of art and to oppose society.[18]

The debate continued throughout 1990 and into 1991. Shortly after the publication of Yang Chengyin's essay, the Ministry of Propaganda, the Association of Writers and Artists, and the Writers' Association held a "Creative Thought Discussion Meeting" to plan strategies for regulating art. Similar meetings followed, and leftist artists and theorists were invited to denounce the poison of capitalist freedom. The art critic Feng Boyi (born 1960) described the situation to his friend Xu Bing in a letter and remarked,

> Most of their statements mentioned you. . . . Gu Yuan [a woodcut artist Xu Bing admired, then vice president of the Artists' Association] made the statement, without mentioning your name, that "there is a very talented artist who in the past took the road of serving the people with his art. Then he came under the spell of foreign thoughts and abandoned the principle of 'art for the people' so as to earn the praise of many people both in this country and abroad. No one can understand his *Book from the Sky*, and it has no meaning. . . . Furthermore, his ideas oppose the tradition of May Fourth."[19]

Du Jian (dates unknown), secretary of the Communist Party at the Central Academy, disagreed with critics of Xu Bing and declared that China must come to terms with Western modernism and Western art language. He believed the New Wave would accomplish this, and the *Book from the Sky* and similar works represented the real future of Chinese art.[20] In response, Li Qun (born 1912), a professor in the Central Academy's print department, who was respected for his role as an early woodcut activist, weighed in with a damning statement.

> I think making *An Analyzed Reflection of the End of This Century* is ridiculous and those who praised it are crazy. . . . Because *An Analyzed Reflection of the End of This Century* does not possess any visual image nor pleasant enjoyment of beauty, not to mention any educational value or inspiring spirit, therefore I do not consider this work as printmaking nor art. . . . It has been known for so many years that the closer the capitalist class reaches its declining period, the more the capitalist artists want to state their lies as truths and display their non-art stuff as art. They try hard to start something new in order to be different; to amaze the world with a single brilliant feat; to win the capitalists' favor and admiration and, there, to use lies to dupe the masses. The Chinese "reseller artists'" painstaking efforts won't make their "reselling art" better.[21]

Xu Bing had been cast as a "bourgeois liberal" artist because his art could not be understood by "the masses." Friends who publicly supported Xu Bing's work laid themselves open to criticism for "contributing to the spread of capitalist freedom," and others were excluded from art conferences by organizers who were reluctant to risk facilitating public praise for Xu Bing. It is no wonder Xu Bing decided to leave Beijing! First he sojourned briefly outside the city, spending a few weeks in May and June 1990 at the Great Wall. There he completed a giant rubbing of the historical symbol of China's age-old efforts to wall itself off from the rest of the world. Mocking his harsh critic—that self-appointed protector of moral values in art, Yang Chengyin—Xu Bing took *Ghosts Pounding the Wall*, the term with which he had condemned the *Book from the Sky*, as the title for the Great Wall rubbing. In July 1990, Xu Bing emigrated to the United States.

25 *Book from the Sky.* Wooden blocks racked for printing.

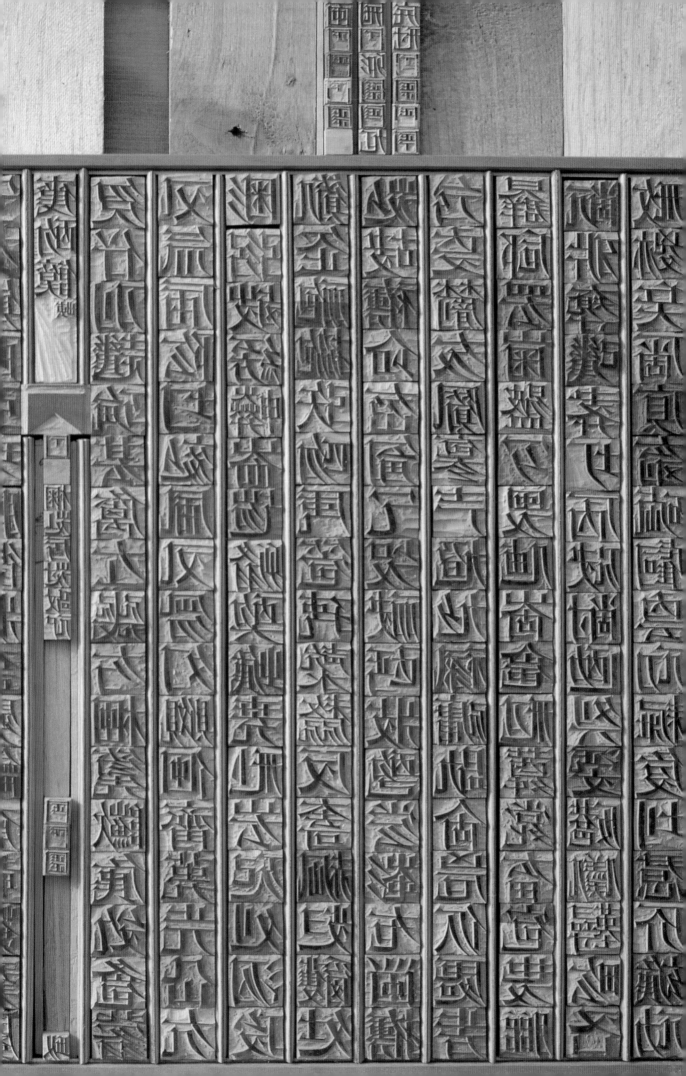

Book from the Sky

The *Book from the Sky* is remarkable for its extreme fidelity to the format and methods of traditional Chinese book arts. Since 1991, three elements—handscrolls, wall panels, and books—have composed the *Book from the Sky* installation. Draping down from the ceiling, the handscrolls take the form of Chinese texts from two thousand years ago, when scribes wrote vertically down strips of bamboo, which they then bound into rolls. After the invention of paper, handscrolls maintained the convention of writing from top to bottom across a horizontal strip of paper. The handscroll portion of the *Book from the Sky* is evocative of Buddhist sutras, which are among the oldest and most important historical handscrolls. *Book from the Sky* wall panels refer to hanging scrolls of calligraphy and have also been likened to wall posters that appeared throughout Cultural Revolution China. Since 1991, the scrolls and wall panels have been mechanically reproduced. Only the books are printed by hand from hand-carved type, and it is the book component that follows tradition most closely in every aspect of its design and production.

All Chinese characters are built up from a limited group of components that are variously combined to create tens of thousands of characters. Xu Bing designed his characters to resemble genuine ones closely. He recombined these genuine components in meaningless formations, sometimes with additional, invented components. A "reader" of the *Book from the Sky* can infer a meaning for some of the invented characters by looking at the component parts. To give a very simple example, if Xu Bing combined a sign for "tree" with an invented sign, we could infer that the character denoted a species of tree.

The number of characters Xu Bing designed for the second version of the *Book from the Sky*—two thousand, including one thousand small and the same one thousand in a larger size—approximates the number of characters needed for basic literacy, that is, enough to read a novel. Xu Bing rendered the "characters" in Song, a popular print style of the Ming dynasty (1368–1644) that he selected for its plainness and lack of emotion. He then carved the characters in reverse into pear wood and typeset the books (fig. 25). Although movable type had been invented in China in the eleventh century, it proved unwieldy and went out of practice because with so many different characters, it proved easier to carve the complete text onto wooden blocks. Xu Bing therefore had to teach the workers at the book factory how to print a book using movable type, a technique he researched at Beijing University.

The four volumes of the *Book from the Sky* are laid out in the format of historical books. Volume one begins with the title page dominated by three oversized characters (*Xi shi jian*). Following the title page is an introduction and table of contents (fig. 26). The contents page is recognizable both by its layout and by the fact that an ordinal number at the bottom of each column indicates the page where the chapter with the title listed above the number can be found. While these numbers are not standard Chinese, they are based on an informal counting system that uses the five strokes in the character *zheng* to count up to five. If only the first stroke is written it denotes one; if

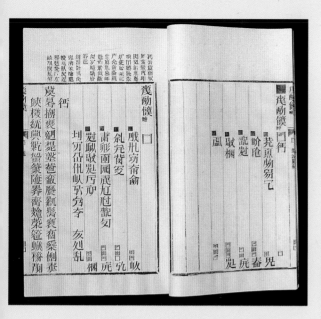

At the book factory, workers printed the four *Book from the Sky* volumes by hand on sheets of *xuan* paper, then folded the sheets and bound them with string binding, all according to tradition. To indicate the books are scholarly in content, they are finished with indigo paper covers to which brown title papers are affixed. As if there could possibly be any doubt that the

the first two strokes appear they are equivalent to two, and so on. Xu Bing placed the *zheng* strokes within a box, thus qualifying his numbers as invented characters, but their meaning is incontestable.

In typesetting the books, Xu Bing selected historical books as models. If the *Book from the Sky* is opened to show the final page of the table of contents on the right and the beginning of the main body of the text on the left (traditional Chinese books are read from right to left) and compared with the corresponding pair of pages in a woodblock-printed book from the Qing dynasty (1644–1911; fig. 27), the similarities in layout are apparent. Passages of the *Book from the Sky* in which double rows of small characters follow single large characters take their form from the Kangxi Dictionary, in which definitions appear in small type following the characters defined. Heavily annotated with dense marginalia are passages mimicking philosophical texts, such as that of the great sage Laozi (604–531 B.C.). There also appear to be poetry, religious texts, and diverse reference works.

set of four books is not what it appears to be—namely, a historical work worthy of reverential status within the hierarchy of Chinese literature—each set rests within a fitted walnut box that was assembled by hand with wooden pegs and dovetailed joints. Only the most important works of literature are accorded such care.

26 Volume 1 of the *Book from the Sky*. Last page of the table of contents and first page of text.

27 Zhao Guohua, *Qingcao tang ji* (Green Grass Hall collection), 1872. Volume 1, *juan* 2 table of contents, p. 1 b–*juan* 2, p. 1 a. Woodblock-printed book, 26.4 x 15 x 1 cm.

Actually, I feel the task of the curator is sometimes meaningless,

because I feel art itself cannot be interpreted through language.

If art could be interpreted through language, there would not

be any reason for the existence of art.[22]

—Xu Bing

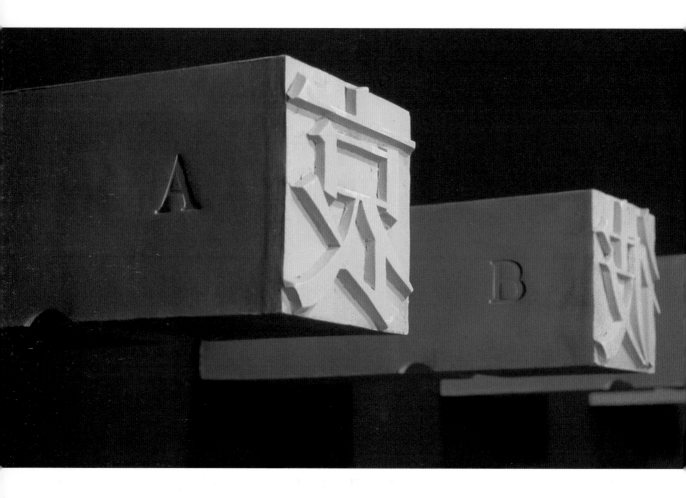

28 *A B C . . .* , 1991. Ceramic blocks, each 8 x 8 x 24 cm.

XU BING plays two kinds of language games: one within his art, and one in what he says about his art. His work often sets up an audience to expect one thing—based on common experience of language—and then it delivers another (fig. 28). At first glance the *Book from the Sky* is totally convincing as a grouping of books, scrolls, and panels printed in Chinese. Upon examining it more closely, however, each Chinese-literate viewer experiences a sudden flash of insight that negates those expectations of readability. In the other form of language game, Xu Bing makes statements about his art—"Any explanation [of the *Book from the Sky*] is superfluous, because the work

THREE

Language as Intellectual Game

itself says nothing"[23]— that are often but not always disingenuous and are certainly at odds with what the art seems to say on its own or with what he has said at another time. Such statements can be frustrating to those who use words in considering art: perhaps they are intended to generate a flash of insight, too. These two varieties of language game are plainly evident in the artist's early years in the United States.

Arriving in Madison, Wisconsin, in mid-1990, Xu Bing found himself strangely displaced. This bibliolater and would-be controller of language understood little English, and almost no one in Madison spoke Chinese. The University of Wisconsin-Madison had invited Xu Bing to take a position as Honorary Fellow. As this afforded him library privileges, he immersed himself in the familiar library realm, commencing an investigation of the Western book tradition. At the same time, he prepared for his first solo exhibition outside Asia, *Three Installations by Xu Bing,* at the university's Elvehjem Museum of Art (November 1991 to January 1992). These two activities—

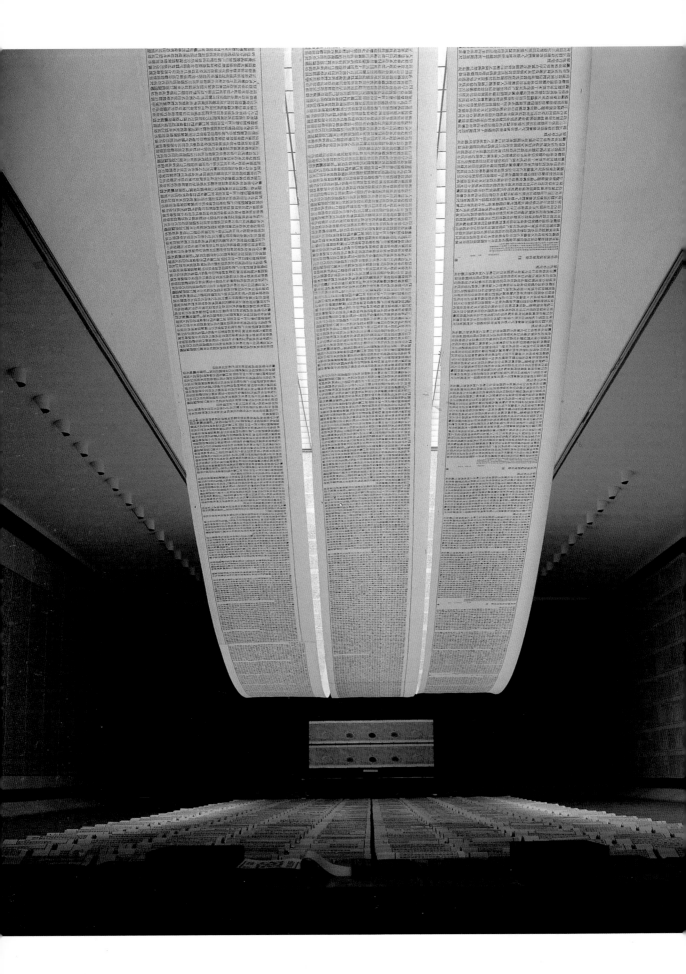

studying the history of Western book arts and putting together a major exhibition in the United States—produced two distinct modes of language play. The former resulted in elegant works of art, first based solely on the Western book tradition (*Post-Testament* and *Brailliterate*), and subsequently combining East and West *(Square Word Calligraphy)*. The exhibition propelled the discourse on Xu Bing's art into a new realm in which he and other international art workers negotiated changing meanings for his more open-ended works (most notably the *Book from the Sky*, but also *Ghosts Pounding the Wall*). Eventually, as commentary on the seeming impossibility of using words to define the meaning of a work of art, Xu Bing created *Wu Street*.

The exhibition *Three Installations by Xu Bing* included *Five Series of Repetitions*, the *Book from the Sky* (fig. 29), and *Ghosts Pounding the Wall*. Such a major exhibition required a catalogue and, as I was the only available person in Madison who spoke Chinese and knew something of contemporary Chinese art, I was fortunate enough to land the task of writing the catalogue essay. The exhibition and catalogue preceded the sudden swell in the number of Western art scholars and critics who were entering the debate over the meanings of Xu Bing's works. They were particularly concerned with contradictions between the works themselves and the artist's statements. Complicating issues were the Tiananmen Square massacre, its prominent role in Western awareness of contemporary China, and uncertainty regarding the extent to which Xu Bing wished to imbue his works with contemporary political relevance. Western writers have tended to link Xu Bing's works—most frequently the *Book from the Sky* and *Ghosts Pounding the Wall* but also later works—with issues of political oppression. Tiananmen is still the glass through which many in the West view China.

When he first moved to the United States, did Xu Bing find it expedient to portray his work as reflecting the political oppression he had experienced in China? Did his audience (including this author) find reflections of political oppression in his art because it expected or wished to do so? Are we faced with a dreaded example of orientalizing or, even worse, auto-orientalizing? Although the truth may contain a bit of both, the fact remains that Chinese government policy had had a severely negative impact on Xu Bing in 1989 and 1990. Following the Tiananmen Square massacre in June 1989, artists and intellectuals had been closely watched and their activities curtailed. Shortly prior to that, the forced closure of the *China/Avant-Garde* exhibition had left artists in a particularly pessimistic frame of mind. Government representatives had singled out the *Book from the Sky* for vilification as representative of all that was worst about the "bourgeois liberal" New Wave art movement, and Xu Bing's

friends and supporters encountered problems due to their association with him. He had found it necessary to move to the United States to continue as a productive and inventive artist.

Book from the Sky and Ghosts Pounding the Wall—two works from the exhibition Three Installations by Xu Bing—have evolved in meaning as they have moved through space and time, sometimes their meaning guided by Xu Bing and sometimes not. Around the time of making the rubbing for Ghosts Pounding the Wall, the Chinese New Wave movement art critic Hou Hanru (born 1963) wrote that Xu Bing had told him "he believed the Great Wall had always been considered a symbol of China's history, but he himself felt that it was no more than an unusual construction, an amusing enclosure, nothing more."[24] In stark contrast to that statement, Xu Bing specifically described to me the work's relationship to the political situation. Talking during the installation of Ghosts Pounding the Wall at the Elvehjem, he said that the Great Wall stands for "a kind of thinking that makes no sense and is very conservative, a really closed-in thinking that symbolizes the isolationism of Chinese politics."[25] Extrapolating from this, we derive the message that, like the regimes that ordered the building of the Great Wall, the Chinese government, in the aftermath of the Tiananmen Square massacre, sought to seal China off from outsiders. Furthermore, just as the Great Wall failed to isolate China, so was the isolationist stance of the early 1990s doomed to failure. Was this message there when Xu Bing originally conceived the plan for Ghosts Pounding the Wall? When did he first see the potential for undermining an icon of Chinese culture, taking the Great Wall to symbolize negative qualities of China rather than the country's greatness? Did the link between historical and contemporary isolationism arise before he came to the United States? Was it there prior to Tiananmen?

Ghosts Pounding the Wall is a somber, overwhelming work. As exhibited at the Elvehjem (the only time this piece has been shown in its entirety), the rubbings of two sides of one of the Great Wall's towers rise up on either side of the walkway rubbing, which drapes down from the ceiling to the floor in a graceful arc and is weighted to the ground by a mound of dirt. As the artist intended, the presence of a large outdoor construction brought indoors oppresses the interior space, conveying the weight of antiquity as well as the weight of the stone mass. This sense of oppression is heightened by the solemnity and rich darkness of the unrelieved black ink with which the rubbing was made. The pile of earth not only provides a compositional weight reminding the viewer of the natural, outdoor setting for the Great Wall, but it also serves as a visual entry point for the viewer. In addition, it contributes a final somber note to the installation: it echoes the formation of Chinese burial

mounds. To ensure that the reference is not lost, Xu Bing folded unmounted rubbings from the Great Wall and weighted them down atop the pile with a large rock. Thus, he refers to the paper spirit money that is left at Chinese tombs for the deceased to use in the afterlife.

Ghosts Pounding the Wall is one example of a work of art whose meaning has evolved since its first conception. In 1987, Xu Bing made a smaller rubbing, *Run of Alignment of the Great Wall,* during the period when Chinese artists felt relatively optimistic about the future. If he had made his statement to Hou Hanru then (instead of in 1990) that the Great Wall was nought but an interesting enclosure, it would have seemed less disingenuous. With *Run of Alignment,* Xu Bing was most interested in demonstrating that a print could be made from any surface, even the irregularly hewn stone of such a crude construction as the Great Wall. By 1990, however, Xu Bing's life had altered dramatically, so much so that he had a revised, pessimistic message to express via his new and larger rubbing of the Great Wall. As the art historian Wu Hung (born 1945) has pointed out, the term "ghost" was used during the Cultural Revolution to describe counter-revolutionaries. When Yang Chengyin described the *Book from the Sky* as an example of "ghosts pounding the wall art," Xu Bing was fast approaching the category of counter-revolutionary. In adopting *Ghosts Pounding the Wall* as the title of his new work, he took for himself the appellation of ghost.[26] Clearly, *Ghosts Pounding the Wall* signals a death knell for Chinese history due to the government's repeated efforts to restrict people, even to the extent of killing those who will not be controlled.

The *Book from the Sky* has a more fluid meaning than *Ghosts Pounding the Wall.* When I interviewed Xu Bing for the Elvehjem catalogue, he encouraged me to focus on the *Book from the Sky*'s political context. A clear link seemed to exist between his meaningless characters and the meaningless texts that had swamped the Cultural Revolution landscape. There was a link, too, with more recent meaningless official publications. Xu Bing had made this explicit with the first version of the *Book from the Sky.* For one volume of it, he had printed pages of the *People's Daily* with his invented characters, obliterating the always suspect verbiage of the nation's most

30 *Book from the Sky.* Invented characters printed on pages of the *People's Daily,* 1988.

important newspaper (fig. 30). It is impossible to know when the *Book from the Sky* acquired political overtones, and Xu Bing now generally avoids discussing them. He has said, "I find it more and more difficult to answer questions that the work raises, even if they are very simple. . . . By offering people many different readings, I found myself in a new predicament. It's as if I turned a simple situation into a more complicated one, falling into a bottomless pit of questions, a culture trap."[27] The game of redirecting the spin on his works has lost its appeal.

31 Discarded paintings used in *Wu Street*, 1993. Photograph by Ai Weiwei. Reproduced with permission of Ai Weiwei.

As a highly cynical comment on the inefficacy of words in clarifying the meaning of art, no doubt occasioned by the volume of commentary that has been written about his own works, Xu Bing created *Wu Street* (1993–94). Walking down Wu Street in New York, the artist came upon some oil paintings that had been discarded on a pile of garbage (fig. 31). He took them home. As he says, they were not very good, but they were not bad either: they were typical au courant mediocre abstracts. Interested in the degree to which language intervenes in an audience's perception of a work of art, Xu Bing—helped by the artist Ai Weiwei (born 1957)—devised an elaborate fiction. First, he located a published article that discussed the abstract oils of a contemporary artist (Jonathan Lasker [born 1948]) in such vague terms that the descriptions could easily apply to the paintings he had found. After receiving permission from Melissa Feldman, the article's good-natured author, Xu Bing substituted photographs of the found paintings for the original illustrations, changed the article's title to "Designing Pictures: The Work of Jason Jones," and sent it to the Beijing journal *World Art* (Shijie meishu). There, it was translated into Chinese and published. No one doubted the authenticity of the article or noticed any disjunction between text and image. Evidently, the language of art criticism is so meaningless that the image substitution had no effect on the article's intelligibility. Or, readers of art criticism are so conditioned to trust the text that any dislocation between what is read and what is seen is conveniently discounted as the result of a deficiency in the reader's understanding.

Too often, people are schooled to rely on the judgment of others when it comes to appreciating art. Fine art is widely understood to be an elitist subject, and the art world does little to change this perception. Very few art galleries exhibit works of art

without prominently displaying the artist's name. If the name is famous, we are reassured that the work is worth contemplating; if unknown, it nevertheless provides an entry point. Xu Bing provided a (fictitious) author for the found paintings and furnished all the hallmarks of art world acceptance and privilege: frames for the oils, forbiddingly intellectual titles, a publication record, and exhibitions in respected galleries, such as the Bronx Museum of the Arts (fig. 32) and the Duke University Museum of Art. When Xu Bing exhibits *Wu Street,* he explicates the process with a display of the original article, the handwritten translation, the layout for the Chinese article, and the issue of *World Art* in which the article was published. The mechanics of the fraud are laid bare. If only the mechanics of the real art world could be so readily exposed, particularly the process by which some works are deemed worthy and others not!

When non-Chinese literate audiences view the *Book from the Sky,* they often miss the primary experience of the Chinese audience: the moment when they discover that their age-old covenant with the written language—very simply, that it is a reliable bearer of meaning—has been shattered. Since his 1990 move to the United States, Xu Bing has been experimenting with different forms of language and books, seeking a means of providing his new Western audience with a similar jolt to the system, to shock viewers out of their complacent acceptance of the value of text. Two early efforts, *Brailliterate* and *Post-Testament,* declare on their title pages that they are "produced by the Publications Center for Culturally Handicapped, Inc." *Brailliterate* (1993), although printed in genuine Braille, is only ever displayed as part of exhibitions of visual art; thus, the text is never available to those who could comprehend it (fig. 33). *Post-Testament* (1992–93) has the

32 Framed paintings in *Wu Street,* each 68.6 x 96.5 cm. Installation view of the exhibition *Xu Bing: Recent Work* at the Bronx Museum of the Arts, New York, July 15 to September 11, 1994. Reproduced with permission of the Bronx Museum of the Arts.

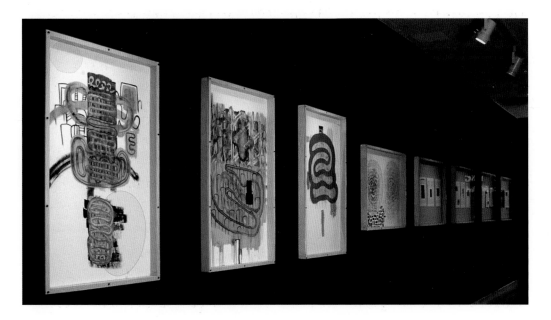

33 *Brailliterate*, 1993. Bound books for the blind, 14 x 11 cm.

34 *Post-Testament*. Closed books, 1992–93. Each 34 x 26 x 6 cm.

35 *Post-Testament*. Open books, 1992–93. Each 34 x 26 x 6 cm.

appearance of a European book from the nineteenth century or earlier. It is printed with metal type on heavy rag paper and bound in gold-embossed calfskin (fig. 34). Contributing further to the aura of antiquity, Gothic lettering adorns the title page, and illuminated capitals introduce each chapter (fig. 35). Those who expect a weighty text in keeping with the book's appearance are left befuddled, for Xu Bing has spliced together the Bible's "begats" with excerpts from a vulgar novel, more or less alternating one word from each. "Thous" and "untos" mix with thighs, heavy breathing, and obscenities. Both form and text make concrete a clash in contemporary cultural values.

While *Brailliterate* and *Post-Testament* were promising efforts to create for Western viewers an experience similar to what Chinese audiences had experienced in beholding the *Book from the Sky*, it was not until Xu Bing came up with Square Word Calligraphy that he succeeded in meeting this goal. He designed Square Word

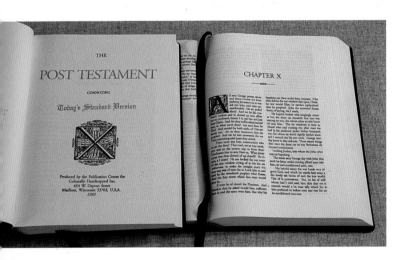

Calligraphy as a new kind of writing, one possibly describable as a font. At first glance it appears to be nothing more unusual than Chinese characters, but in fact it is a new way of rendering English words in the format of a square so they resemble Chinese characters. He adheres to tenets of Chinese calligraphy practice as closely as possible, thus enhancing the illusion.

Chinese viewers expect to be able to read Square Word Calligraphy but cannot. Western viewers, however, are surprised to find that they *can* read it. Delight erupts when meaning is unexpectedly revealed.

Square Word Calligraphy is not Xu Bing's first attempt to create a new form of writing by combining English and Chinese. In 1987, while work on the *Book from the Sky* was in its early stages, Xu Bing produced the *Book from the Sky Translation*. This was his first piece to combine English and Chinese. *Book from the Sky* characters fill half of each page, with an unintelligible "English" translation occupying the other half. Next

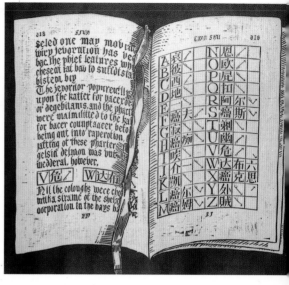

36 *My Book*, 1992–unfinished. Woodcut on paper, 45.7 x 533.4 cm.

came *A B C . . .* (1991), an initial step into investigating the possibility of using Chinese characters to communicate in English. A set of ceramic printing blocks comprises *A B C . . .*, each bearing a Chinese character whose pronunciation is roughly equivalent to that of one letter of the Latin alphabet. For example, *ai* (sounds like "eye"; to mourn, be sorrowful) stands for *a*, *bi* (the other side) for *b*, *xi* (sounds somewhat like "she"; west) for *c*, *di* (sounds like "dee"; place, ground) for *d*, *yi* (sounds like "ee"; one) for *e*, and so on (see fig. 28). *My Book* (1992–unfinished), a segment of a "Repetitions" print (produced in the same manner as *Five Series of Repetitions*), displays the entire sequence of letters with the corresponding Chinese (fig. 36). Ostensibly, *A B C . . .* represents a harmless personal code based logically on the premise that different symbols for the same sound might as well be interchangeable. Xu Bing did not, however, base his choice of characters on their pronunciation alone. If, after spelling out English words using Xu Bing's set of phonetically equivalent Chinese characters, one then reads the Chinese message for meaning rather than sound, the result can be humorous or subversive.

Close to a decade elapsed between Xu Bing's creation of the *Book from the Sky* and *Square Word Calligraphy*. In that time, a diametric shift occurred in the artist's representation of language. The earlier work presents a view of language as overwhelming and frustrating, and the latter suggests language's power to unify and delight. It is impossible to avoid the conclusion that, for Xu Bing at least, communication in the late 1990s was easier and more rewarding than it was ten years earlier. Xu Bing's efforts to bring Square Word Calligraphy to a wide public audience so as to demystify Chinese culture and to share the pleasures of calligraphy have become a keystone of his growing drive to "serve the people."

37 *An Introduction to Square Word Calligraphy,* 1994–96. Instructional page on wielding the brush. Paper, 41.3 x 27.3 cm.

38 *An Introduction to Square Word Calligraphy,* 1994–96. Instructional page showing the left falling stroke, "like an elephant tusk, not a mouse tail." Paper, 41.3 x 27.3 cm.

Square Word Calligraphy

Like the *Book from the Sky,* Square Word Calligraphy is deeply rooted in Chinese tradition. Xu Bing created a set of two books, *An Introduction to Square Word Calligraphy* and *Square Word Calligraphy Red Line Tracing Book,* to teach his new form of writing. The first book is instructional, beginning with directions for holding the brush and rendering the brushstrokes. The directions themselves are written in Square Word Calligraphy. First of all, the student of Square Word Calligraphy must learn how to prepare ink by grinding the ink stick with water against the inkstone. (Of course, many people now use bottled ink, but *An Introduction to Square Word Calligraphy* adheres rigorously to tradition.) Before attempting to write anything, the student then must master the correct posture and method of holding the brush (fig. 37). This concurs with traditional calligraphy instruction. Sitting upright, the calligrapher holds the brush perpendicular to the paper, poised in the air, while he marshals his forces to begin. Sloppy posture equals weak calligraphy. Xu Bing illustrates the posture with a rare self-portrait.

The eight different kinds of brushstrokes most frequently employed in Chinese calligraphy come together in the character *yong,* meaning eternal. For this reason, beginning calligraphers traditionally study *yongzi bafa,* or the "Eight Strokes in the Character *Yong.*" Xu

Bing has beginners of Square Word Calligraphy learn the "Eight Movements of the Word Lag." He augments the lengthy descriptions of just how to render each movement or brushstroke with instructive illustrations. The horizontal stroke, for example, should be strong and taut "like a bridled horse, not a rotted log," and the brush movement for a left falling stroke should be "like an elephant tusk, not a mouse tail" (fig. 38).

Following the instructions are pages of sample writing in the traditional format of *beitie*, calligraphy style models originally made by taking rubbings from stone carvings of exemplary texts, but later simply printed to resemble rubbings. Although they bear the ostensible appearance of traditional models for calligraphy, the content of Xu Bing's *Introduction to Square Word Calligraphy* is highly unusual: English nursery rhymes (fig. 39).

The second book in the set is a "red line" tracing book. The calligraphy student practices by writing over the characters, which are printed in red outlines with numbers indicating the order of the brushstrokes (fig. 40). The stroke order within each square word follows the stroke order of Chinese characters. When Xu Bing writes poems or narrative passages in Square Word Calligraphy, he uses the traditional formats of hanging scroll, album, fan, etc.

39 *An Introduction to Square Word Calligraphy*, 1994–96. Style model page of "Little Bo Peep." Paper, 41.3 x 27.3 cm.

40 *Square Word Calligraphy Red Line Tracing Book*, 1994–96. Calligraphy practice page of "Little Bo Peep." Paper, 41.3 x 27.3 cm.

Ma Yan: "What is your intention in creating [the *Book from the Sky*]?"

Xu Bing: "I want to remind people that it is culture that restricts them." [28]

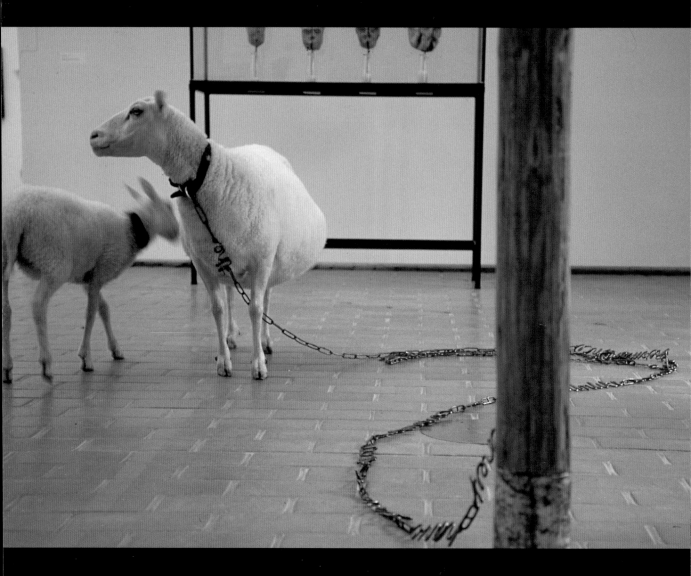

41 Detail of *Net and Leash,* with two sheep in cage, 1998. Installation with steel, wire, wood, sheep. Installation view of the exhibition *Animal. Anima. Animus.* at the Pori Art Museum in Pori, Finland, June 6 to August 30, 1998. Reproduced with permission of the Pori Art Museum.

To Xu Bing, language—particularly but not exclusively written language—is the key to being human, and it lies at the crux of human culture. Furthermore, while culture presents great benefits, it also has walled off areas of experience to us. Xu Bing has discovered that he can engineer situations in which interactions with animals will drive these points home to his audience. The form of interaction varies from detached observation to visceral involvement. For his ongoing *Can* (or *Silkworm*) *Series,* begun in 1995, he installs an assortment of objects redolent of advanced civilization (texts such as newspapers and old Chinese books, computers, VCRs) and has silkworms cover them with silk to convey the idea that nature has absolutely no interest in human creations.

To Be Human

A Case Study of Transference (1994) was planned with a similar message in mind. The artist filled a fenced-in area with open books and then placed a pair of pigs, who had been printed with unintelligible text, in the pen to mate. They mated with no regard for the texts on their bodies or what was underfoot. What most forcefully underscored to the audience their differentiation from animals was the fact that while the pigs felt no embarrassment mating in public, the audience members were extremely uncomfortable watching.

In 1998, Xu Bing created *Net and Leash,* an installation that highlighted language as a mechanism of control available only to humans (fig. 41). He commissioned a leash of wire words and a cage whose mesh sides were made of wire formed into the shape of words. The wire constituting the cage recreated the text of the exhibition statement; thus, the words were doubly the means whereby the cage was formed. When viewers of *Net and Leash* look into the cage, they find their gaze returned by the placid gaze of sheep. Viewers contemplate the role of humans in imprisoning animals, and they also consider ways in which people confine each other through words.

When Xu Bing lived in the village of Huapen, he and the other rusticated youth with whom he formed a household shared responsibility for raising a pig. The village possessed communal pigs that lived in a special shed and were tended by a farmer well versed in animal husbandry. Individual households were allowed to raise privately owned animals as well, caring for them when daily labor in the communally owned fields had been completed. Xu Bing learned a great deal about pigs, as the students' pig lived in a pen adjoining their house.[29] The impression he formed then was that pigs are both intelligent and primitive, harking back in spirit to some primal era. Xu Bing has used pigs in a long succession of performance and installation works because of his longstanding familiarity with the animal, and his sense that they are

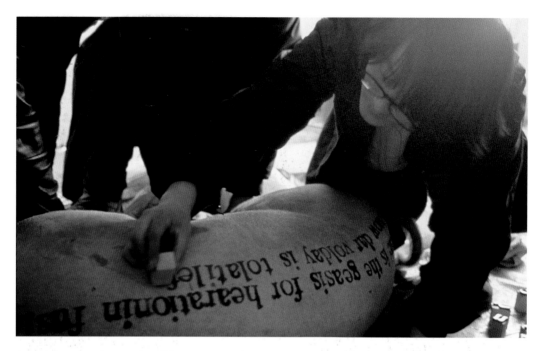

42 *A Case Study of Transference.* Printing on pig prior to performance, January 22, 1994. Han Mo Arts Center, Beijing. Photograph by Ai Weiwei. Reproduced with permission of Ai Weiwei.

43 *A Case Study of Transference.* Performance with pigs and books, January 22, 1994. Han Mo Arts Center, Beijing. Photograph by Xu Zhiwei. Reproduced with permission of Xu Zhiwei.

intelligent enough to cooperate with man and yet are abidingly primitive.

A Case Study of Transference, Xu Bing's first work involving animals, took place at the Han Mo Arts Center in Beijing on January 22, 1994. The performance was staged only once for an invited audience because widespread publicity would have drawn unfavorable attention to the Han Mo Arts Center. Despite the brevity of the exhibition, the work involved lengthy planning. Xu Bing visited several pig breeding centers before finding a male and a female pig that would be likely to mate with one another—pigs can be quite selective—and with whom the pig farmers were willing to part. The chosen male pig was not sexually experienced—since he had not proven himself, he was not as valuable to the farmers as were other male pigs—and required training via "frame mounting." Finally, both pigs were as ready as they were likely to be for their performance. In the arts center Xu Bing prepared a pen, strewn with open books in many languages. Then he and several assistants printed the pig's pale pink skin with orderly rows of *Book from the Sky* invented characters (on the female) and invented English words (on the male; fig. 42). Even with the great care invested in the preparations, a very real possibility remained that the pigs would not mate. They might be disoriented, the crowd of observers might frighten them, or it might simply be the wrong timing for the animals.

The audience was not disappointed: the pigs performed at length, mating repeatedly with the utmost abandon (fig. 43). This supported the interpretation that

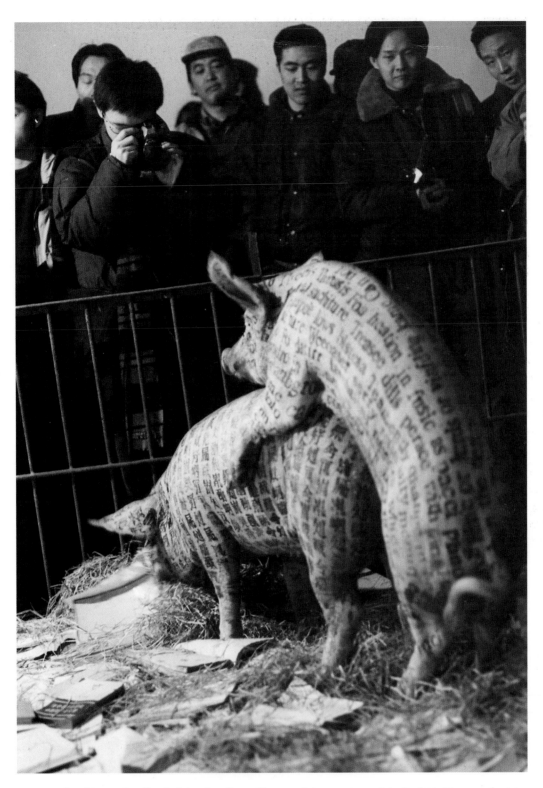

Xu Bing had imagined might arise from the performance: animals do not care about culture, and instinct will not be subsumed by a superficial layering of culture (the text covering the pigs' bodies) or cultural surroundings (the pen filled with books). Unexpectedly, the audience's reaction created a new layer of meaning. Many observers were extremely uncomfortable witnessing the sights and sounds of such

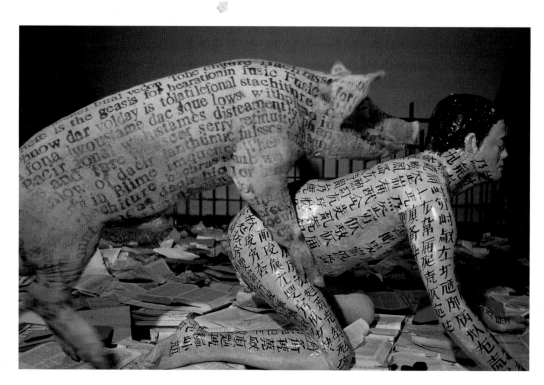

44 *Cultural Animal*. Performance with pig and model of human, January 23, 1994. Han Mo Arts Center, Beijing. Photograph by Ai Weiwei. Reproduced with permission of Ai Weiwei.

raw and unashamed sexual activity. They made nervous conversation as a distraction and seemed uncertain otherwise where to look. Clearly, culture has made people anxious about their own animal nature. As Xu Bing later remarked, "People and pigs are completely the same, except culture has changed people."[30]

When Xu Bing first conceived of this performance in 1993, he gave it the Chinese title *Wenhua dongwu* (Cultural animal) and thought about having humans as performers. If that version of the project had been realized, a different message would have emerged: people's sexuality overcomes their layers of culture conditioning. A third version, with the male pig and a human mannequin, took place at the Han Mo Arts Center the day following the "public" event (fig. 44). With its numerous symbolic juxtapositions *(animal–human; male pig–male human; live animal–lifeless human; fake Chinese–fake English)* fraught with emotional values, it could give rise to an interpretive feast.

Two important lessons came out of *A Case Study of Transference*. First, culture can be a limiting factor in human experience, distancing human beings from an essential aspect of their nature. Second, if the artist brings together elements charged with emotional overtones (sex, trampled books, "Chinese" equated with female, "English" with male), and then allows for the action of unpredictable factors (here, the pigs and the audience), a powerful performance may result. A video — also titled *A Case Study of Transference* — documenting the search for the proper pigs, the performance, and the audience reaction has been widely exhibited since the mid-1990s.[31]

Having established the potential power in animal performance-installation pieces, including the ability of animals to make humans contemplate their *soi-disant* status as superior beings, Xu Bing purchased a pair of parrots in Beijing and had them trained to issue provocative statements for his performance piece *Parrot* (1994–95). From a cage one bird exclaims, "Why are you holding me prisoner? You bastards!" A second bird on a perch announces, "Humans are so boring! Modern art is crap!" Hearing the second parrot's messages might not be worthy of note coming from a human, but coming from an animal they tend to give pause.

Silkworms are Xu Bing's second major animal collaborators. Both creatures are important in Chinese culture: pigs as a prominent source of meat, and silkworms as the ancient source of a singular Chinese product, silk. First installed in the artist's solo exhibition *Language Lost* at the Massachusetts College of Art (September 18 to December 22, 1995), *Can Series* juxtaposed animals and text, as had *A Case Study of Transference.* Also like *Case Study,* it required lengthy preparation. Timing it so that the eggs would hatch during the exhibition, Xu Bing placed egg-laying moths on the open pages of books, the pages of which were blank except for strips of paper (fig. 45). When the egg laying was complete, the paper strips were removed. This left rows of black eggs that mimicked the form of books with their rows of text (fig. 46). Beginning as black dots reminiscent of Braille, the eggs soon hatched to produce tiny larvae that wrought havoc on the orderly arrangement. Text appeared to squirm about and wander off the page. The character *can,* silkworm, is homonymous with a different *can* character that means to damage or disfigure. This is what happens with the printed word in the *Can Series.* The unreliability of the printed word as a bearer of constant meaning is the first message of the *Can Series.*

When the larvae grew into fat white creatures, they began spinning silk to create a safe cocoon within which they would evolve into moths. For the *Can Series,* Xu Bing placed them upon old Chinese books, Cultural Revolution artifacts, newspapers, and a computer with a flickering, text-filled monitor. The larvae spun their silk in layers across the flat surfaces, gradually obscuring the text until they finally found a suitable corner to anchor the cocoon they had been waiting to build (fig. 47). The second message is here: nature has absolutely no interest in the human creation of writing. Furthermore, through tireless industry nature may prevail over human culture.

Parrot noted the inequality of the species, with one able to hold another captive. Is wielding such power part of being human? Is feeling that it is just to entrap another being a unique human attribute? Xu Bing further explored such questions with the paired works *Net and Leash* (see fig. 41), which he created for the exhibition *Animal. Anima. Animus.* at the Pori Art Museum in Pori, Finland (June 6 to August 30,

45 Xu Bing arranging moths for egg laying for *Can Series*, 1995. Silkworm moths and books.

46 *Can Series*, 1995. Silkworm eggs on book.

47 *Can Series*, 1995. Silk and cocoons on book, on board, 56 x 56 x 12 cm.

1998). Fifteen international artists participated in this exhibition, variously using animal parts, representations of animals, or animal activity to create their works. Of the fifteen, only Xu Bing encouraged and provided the opportunity for viewers to interact with animals.

Trailing across the floor of the gallery, the leash leads to a wandering sheep. Elongated links alternating with lengths of wire shaped into words form the leash. Visitors who examined the leash closely, perhaps trailing it through their fingers as they followed the words from link to link, discovered that they were reading "They Are the Last," by John Berger, a poem about humans' complacent acceptance of animals' quiet grace.

The net portion of *Net and Leash* is a large cage, roughly a cube two meters on each side in size. Forming the mesh sides of the cube, wire is bent into row upon row of linked words, joining in sentences that are entirely legible upon close examination. The text derives from the exhibition statement, making the words not only the physical cage for the animals but also the motivation for the cage's fabrication. Two sheep, a ewe and her lamb, were penned in the cage, but only for brief periods, out of respect for the animals' needs. In the context of the museum, the fact of the animals' captivity was much more noticeable than it would have been on a farm. People were led to consider the nature of such an existence, and their own de facto role as animal captor. Looking through the mesh, sheep and human gazes met. Is language all that separates us from other animals? Resting placidly within the cage, the sheep seemed innocent and accepting of their situation, hardly noticing they were caged. Could it be that we exist in cages, unaware of others' devising? Words can put limits on our freedom as well.

Domesticated mammals such as pigs and sheep are close enough to us that we can identify with them, and yet they are distant enough that we can observe them with detachment. Xu Bing sets up situations in which we can flash between these

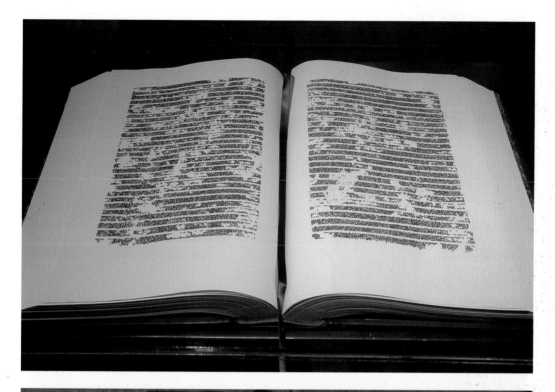

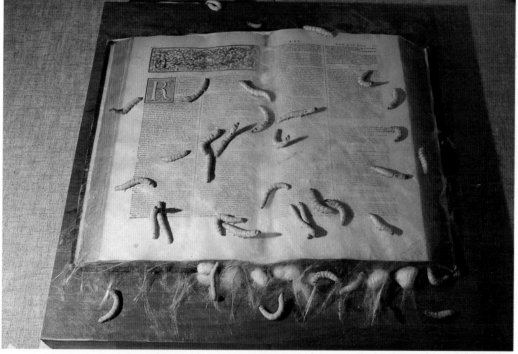

two perspectives, identifying and then observing dispassionately. At some point as we cycle between the opposing perspectives, we find that we are observing ourselves. *Net and Leash* and *A Case Study of Transference* teach us something about ourselves, about what is it to be human, and about what we *think* it is to be human.

人民同在

献给

1989

为民

主自

由

而

参

加

绝

食

团

Like many intellectuals of his generation, Xu Bing adheres to the Maoist creed of "serving the people." During the Cultural Revolution, of course, all art was required to serve the people, and Xu Bing took his role as "art worker" very seriously. As a youth he co-produced illustrated newsletters for the peasants in the village of Huapen, where he had been sent. At the Central Academy of Fine Arts, he was a particularly dedicated teacher. When regional art clubs invited him to direct workshops, his level of dedication was extraordinary. In 1985, at the Longyang Hydroelectric Dam workers' art association, for example, he sketched the construction at night and created etchings from the drawings during the day, using metal plates and tins of acid he had lugged from Beijing. In support of his students demonstrating in Tiananmen Square in 1989, Xu Bing created a protest poster that was prominently displayed (fig. 48).

Serve the People

The idea of serving the people became much less of an issue for Xu Bing after he moved to the United States. It lay dormant until he achieved prominence in the international art world. As an artist in increasingly high demand, Xu Bing began making the rounds of periodic international exhibitions, the biennials and triennials. He realized two things. First, most cutting-edge contemporary art is exceedingly elitist, created for a very small audience of cognoscenti. Second, he was spending most of his time flying from place to place, evaluating gallery spaces as potential venues for his works of art, flying some more, ordering materials, flying, installing works of art. After a while this routine became exhausting and left little time for creativity. The energizing idea surfaced that he might rededicate his art to serving the people. His notion of how best to do this may not always agree with what China's government promoted in the past. Nevertheless, he is sincere in his belief that art should serve a social purpose and should not be confined to exercises understood by a rarefied art world elite.

In a 1999 interview, Xu Bing described the way he believes his art relates to society and to the individual.

> [Chinese] artists my age do all feel a sense of responsibility. Definitely. You can see it in the work. But if you're asking if I feel my work is done to reform or change society, then I don't think so. At least not directly. I feel I am finding a way to take what is valuable in Chinese culture and bring those things into contemporary society. I think the real meaning of what I do is in that aspect of my work. . . . Of course when I am working I consider how it will be received by society and how it will impact society, whether or not it will have any meaning or benefit to society. I consider whether or not it will be meaningful or

beneficial to people. I hope my work will reach the broadest spectrum of people possible, everybody from the art expert to the average person. I don't feel my work has a limited audience at all. I think that if people have any feeling at all they can appreciate my work.[32]

Square Word Calligraphy has proven to be Xu Bing's most powerful tool in his effort to "bring art to the people." Installations based on this new way of writing have graced galleries and museums throughout the world since 1996. These presentations demystify the Chinese language, initiate Westerners into the joys of Chinese calligraphy, and generally proclaim the possibility of unexpected rewards for those who make the effort to communicate across cultures. The installation *Classroom Calligraphy* alone has appeared in Munich, Uppsala, Copenhagen, Berlin, Boras, Johannesburg, Valencia, London, Majorca, Kwangju, Vancouver, Mitaka, Taipei, Pittsburgh, New York, Tokyo, Birmingham, Brisbane, Chicago, Boston, Sydney, and Prague. While Xu Bing's obsession with language and cross-cultural communication spurred his invention of Square Word Calligraphy, he has created subsequent works that are consciously motivated by his desire to make "art for the people." For an exhibition at the Museum of Modern Art in New York City in 1999, Xu Bing designed a banner announcing "Art for the People" to proclaim his newly solidified belief in the primacy of this creative motivation. For the Sydney Biennale the following year, he created a work with Sydney-siders in mind as an audience just as much as art workers. (Most participants in periodic international exhibitions take the opposite approach.) Recently, Xu Bing was overwhelmed by the poverty he saw when he participated in a Himalayan trek organized by the Kiasma Museum of Contemporary Art in Helsinki, Finland. For an exhibition at the Kiasma, he designed an installation that directed money to impoverished Nepalese.

For Xu Bing, a breakthrough in thinking about languages came when the *Book from the Sky* was first exhibited in the West, and he observed the attitude of awe and respect with which non-Asians regard Chinese writing. Intrigued, he sought to create a work that would demystify calligraphy and reward the Westerner's engagement. The result was Square Word Calligraphy, a writing system that appears to be Chinese but is composed of English words written in the form of a square. Xu Bing has set up classrooms for teaching Square Word Calligraphy in many parts of the world (fig. 49), and he encourages museum outreach programs to take Square Word Calligraphy to schools. In this way he hopes to introduce people to a realm previously considered too obscure and elitist to bear trespassing by the uninitiated. Desks set for use with Square Word Calligraphy copy books, inkstones, brushes, and other writing utensils fill the exhibition gallery. When visitors take up the brush and begin working on a page of the red-line copy book, the process of demystifying Chinese calligraphy

begins. Eventually, when they realize that they are writing nursery rhymes in English rather than unfathomable excerpts from the Chinese classics, they comprehend that it is not necessary to feel intimidated by Chinese calligraphy.

49 *Classroom Calligraphy,* 1995. Installation view of the Institute of Contemporary Art, London. Reproduced with permission of the Institute of Contemporary Art.

In *An Introduction to Square Word Calligraphy,* Xu Bing emphasizes the notion that practicing calligraphy has far greater significance than simply mastering a new way of writing.

> "Calligraphy" is by nature different from "writing." It is not merely a tool of communication, but also an activity that combines both artistic expression and spiritual energy. From the first stroke of a word to its completion, our entire bodies are involved. It is a process of communing with nature, of experiencing consummate beauty, and of discovering our inner selves. Through this practice, our minds, bodies, and thoughts will enter a new realm.[33]

All this, of course, is written in Square Word Calligraphy, making it something of a mystery, but untangling the calligraphy to discover the words' original forms and meanings is both engrossing and relaxing. In fact, the process of reading the instructional book becomes a meditative passage, one that parallels the contemplative state of mind required of the calligrapher. The words begin to look familiar, hinting that

calligraphy, too, may not be as alien and its mastery as unattainable as its mysterious aura implies. As Xu Bing says, "We will quickly learn to enjoy putting the instructions in this book into practice. By doing so, we will experience something we once thought impossible. It will help us rediscover things that have been forgotten and now seem strange to us. For actually, these things have always belonged to us."[34]

Square Word Calligraphy presents seemingly limitless possibilities besides the classroom installation. Central to its first variant, *Please, What Is Your Name?,* is a computer program that prints out gallery visitors' surnames written in Square Word Calligraphy. Soon a computer program will be capable of converting any text entered in the Latin alphabet into Square Word Calligraphy, making the calligraphy a true font. Another planned project will take Square Word Calligraphy back in time, rendering it even more faithful to traditional Chinese calligraphy models. Xu Bing plans to have the pages of model text carved into stone so they can be reproduced as rubbings.

The artist's ultimate goal is to popularize Square Word Calligraphy to such an extent that everyone outside China can have the opportunity to enjoy practicing calligraphy in a Chinese mode. Ideally, people should be able to employ the useful tool of Square Word Calligraphy outside institutional settings, at home or school, for pure pleasure, to write letters, or as decorative lettering. Xu Bing uses his status as a respected artist to place this practical and enjoyable way of writing inside museums and galleries, hoping it will spread around the globe. Theoretically, once Square Word Calligraphy has been converted into a computer font, it will escape the art institutional setting and spread even faster.

For the exhibition *Projects 70: Shirin Neshat, Simon Patterson, Xu Bing,* he and two other artists were invited to create banners that hung as works of art on the exterior of New York City's Museum of Modern Art, where even those who were not going to the museum could see them (see fig. 3). The creed of "art for the people," while not expressed by Mao in exactly those words, was laid down by that Chinese leader in his 1942 "Talks at the Yanan Forum on Literature and Art." He cited Lenin as having solved the question of audience: "Lenin pointed out emphatically that our literature and art should 'serve . . . the millions and tens of millions of working people.' "[35] In popular parlance, the creed was shortened to "art for the people." Xu Bing's banner at the Museum of Modern Art utilized these four words as a quotation of Mao. Written in gold Square Word Calligraphy against a red background, the creed combines the visual feel of a joyous pronouncement (such as Happy New Year!) with the utilitarian purpose of a public sign, such as the name of a business, both of which frequently employ gold against red. The banner insists on revolutionizing public museums and their contents, so that art will be more intellectually accessible to the public.

50 *Landscript*, 2000. Ink mixed with paint on window panes, approximately 35 x 200 m. Installation view of the Biennale of Sydney 2000 at the Art Gallery of New South Wales. Reproduced with permission of the Art Gallery of New South Wales and the Biennale of Sydney, Ltd.

Xu Bing attributes his seemingly fearless attitude toward forging a new path in art to his childhood revolutionary training. In school his report cards always stated, "Deficient in the Red Guard's spirit of the Five Courages." In response he strove to improve his courage to think, act, speak, resist, and make revolution. "After living through [that, as well as] all of the turmoil at Beijing University, what would there be that would seem impossible to change?"[36] Apparently, not even long-entrenched attitudes pervading major Western art institutions were exempt.

For the Biennale of Sydney 2000, Xu Bing produced a playful piece by covering the huge plate glass windows on the ground floor of the Art Gallery of New South Wales (fig. 50). In *Landscript*, ancient pictographic forms of Chinese characters came together with words written in Square Word Calligraphy in a landscape of buildings and vegetation. Visitors to the exhibition who stood on a star painted on the floor could see the painted landscape of words line up exactly with the landscape beyond the window. The pictographic form of the Chinese character for "tree" resembles a tree. *Landscript* obscured the trees in the outdoor landscape with images of trees that were also words for trees. Similarly, the Square Word Calligraphy rendition of "flat"

51 *Helsinki-Himalaya Exchange*, 2000.
Ink on two sheets of paper, together
approximately 1 x 3 m.

(apartment) is boxy. In *Landscript*, the artist placed piles of Square Word Calligraphy "flats" between the viewer and the multistoried apartment buildings across Sydney Harbor. Ultimately, *Landscript* is a rendition of the landscape in a provocative conglomeration of words and picture—words that are entirely legible as a landscape without referring to the cityscape on which it is modeled.

While *Landscript* is hardly lacking in intellectual content, its playfulness and its design for the people of Sydney set it apart from other works of art in the Biennale. Conceptual art does not generally address itself to a lay audience. Few tourists or school children stopped to look closely at most of the works shown in the Biennale. The point of many works and installations was too obscure or subtle, and they lacked any qualities that might initially capture general attention. *Landscript*, by contrast, was fun. School children took turns standing on the star, laughing as the painted words and the landscape lined up. Older visitors stood on tiptoes or crouched to determine the artist's height (and thus the best position from which to view the work).

Before he created *Landscript*, Xu Bing had been thinking for several years about the possibility of painting landscapes with words. He produced a series of small sketches based on this idea in October 1999 while he was trekking through the

Himalayas. In a later sketch of layered mountains separated by mist, for example, he rendered the foreground grasses using the Chinese character for grass, built up mountains from the characters for mountain, stone, and trees, and wrote "white" in Chinese at intervals in faint ink across areas of mist (fig. 51). The Kiasma Museum of Contemporary Art in Finland organized this Himalayan trek for six artists from different countries, with the idea that each artist would express the results of that arduous journey undertaken with strangers through unfamiliar territory in works that would be shown in a later exhibition.

Xu Bing expected the experience of walking through forbidding terrain and living under rough conditions to be reminiscent of his life as a volunteer art worker visiting remote Chinese villages and factories during the late 1970s and early 1980s. He had thought the Nepal trek would help him to cast his mind back to that time, when he had thoroughly internalized the concept of "art for the people." To his surprise, however, he found that he had been changed by his life in the United States to such an extent that he could no longer identify with the peasants. He expressed his feelings about this discovery eloquently.

In the autumn of [1999] I went to Kathmandu with the same sort of mental and emotional preparation as when I had gone to the Chinese countryside before, yet as I took a

pedicab from the airport to the hotel I began to feel that things were not quite as I had expected.... None of [the artistic approaches that came to mind] felt right. Why? Because I was not used to looking through those eyes, the eyes of the pitying, objective observer or an intellectual, thinking, "What can be done for these people?" I was also not used to looking from the vantage point of the supposedly highly civilized and looking down with fascination on unchanged cultural traditions and customs.... I began to feel the strangeness of my own eyes. These were the eyes of Western tourists that I had myself seen before in China—but from the other side.[37]

The poverty of the region impressed Xu Bing deeply, and he became determined to devise a way to help. The installation he created for the exhibition *DELICATE BALANCE: Six Routes to the Himalayas,* held at the Kiasma Museum of Contemporary Art, was meant to heighten outside awareness of the Nepalese people's poverty and to provide some financial assistance (fig. 52). Landscapes based on the small sketches Xu Bing had made in Nepal and rendered in Chinese ink on Nepalese paper lined the walls of a gallery. Dominating the center of the room was a replica of a red donation box and a wooden platform from the Himalayas. Visitors to the exhibition were invited to take a packet of postcard reproductions of Xu Bing's Nepal sketches, and in return they were requested to make a donation to help the people of Nepal.

In 1990, Gu Yuan criticized Xu Bing for abandoning the principle of "art for the people." Xu Bing admired him, and the

52 *Helsinki-Himalaya Exchange,* 2000. Nepalese paper, ink, wooden box, wooden platforms, and postcards with envelopes, approximately 20 x 80 x 30 m. Installation view of the exhibition *DELICATE BALANCE: Six Routes to the Himalayas* at the Kiasma Museum of Contemporary Art, Kiasma, Finland, June to September 2000. Reproduced with permission of the Kiasma Museum of Contemporary Art.

harsh words must have stung. If the older artist were still alive, it would be difficult for him not to admit that Xu Bing is sincere in his efforts to put his art to the service of the people of Nepal. Whether Gu Yuan could recognize the same principle of service in the younger artist's other recent projects is unclear. "The people" whom Xu Bing now aims to serve with his art are different from the uneducated workers, peasants, and soldiers he served as an art worker in 1970s China. Then, he taught art classes in remote locations and created etchings, woodcuts, and sketches that reflected the people's everyday lives. His art was representational and could be understood by almost anyone. Now a leading international conceptual artist, Xu Bing has been performing on a sophisticated level for over a decade, devising art of sometimes daunting intellectual content.

Rediscovering the value of serving the people provides an extra challenge, one that arguably bumps his work to an even higher level of sophistication. His art must satisfy the hypercritical art world elite before he can gain the platform of international exhibitions from which he is then able to reach the public. To serve the general public, he must create art that connects with that world in a meaningful way, drawing viewers in and fostering a desire to learn more about art or culture or the experiences of others. Language-based pieces such as *Classroom Calligraphy* and *Landscript,* and animal pieces *(Net and Leash)* have delighted and educated diverse audiences while they draw critical acclaim. Their immediacy and playfulness appeal to jaded as well as untried palates.

As in his years at the Central Academy of Fine Arts in Beijing, Xu Bing has managed to find a creative space for himself within the tensions that stretch between the seemingly contradictory demands of disparate audiences. Whether they fully realize it or not, both elite and lay audiences are treated to a glimpse of the other's point of view, just as sheep and humans gaze at one another across a cage of words, and as Chinese-literate and English-literate audiences find a window into each other's experiences with language via Square Word Calligraphy. Xu Bing has faced cultural quandaries all his life, but his ability to analyze his circumstances and represent them to others in universal terms has turned those dilemmas into catalysts for revolutionary creative ventures.

NOTES

1 As quoted in Jennifer Eagleton, "Overview of the Rustication Program," *Education about Asia* 4, no. 3 (winter 1999), 7.

2 *Xu Bing's Small Woodcuts* (Changsha: Hunan People's Art Publishing House, 1986), 8.

3 Telephone conversation between Xu Bing and the author, June 13, 2000.

4 *Xu Bing's Small Woodcuts*, 9.

5 Scott Minick and Jiao Ping, *Chinese Graphic Design in the Twentieth Century* (London: Thames and Hudson, 1990), 77.

6 *Zhongguo meishu bao* (Fine arts in China) 37 (September 15, 1986): 1; 50 (December 15, 1986), 2.

7 For Xu Bing's drawing philosophy, see Xu Bing, "Sumiao xunlian: guangyi he xiayi" (Drawing instruction: Generally speaking and in practical terms), *Meishu yanjiu* (Art research) 4 (November 1988), 36–39.

8 For more about Soviet-style (Chestyiakovian) drawing instruction, see Duan Lian, "The Way from Outside In: A Pedagogical Study of the Chestyiakovian System of Teaching Drawing and Its Influence on Chinese Art Education," master's thesis, Concordia University, Montreal, 1995.

9 E-mail correspondence from Feng Mengbo to the author, November 20, 1999.

10 Roland Barthes (1915–1980) was a French social and literary critic and theorist. The work of French philosopher Jacques Derrida (born 1930) originated the school of deconstruction as applied to literature, linguistics, and philosophy. Michel Foucault (1926–1984) was a French philosopher who explored people's assumptions of permanent truths.

11 Song Xiaoxia's interview with Xu Bing, February 2000.

12 Xu Bing, "To Frighten Heaven and Earth and Make the Spirits Cry" (artist's statement), in *The Library of Babel* (Tokyo: NTT InterCommunication Center [ICC], 1998), 69.

13 Author's interview with Xu Bing, August 1999.

14 The cultural historian Sang Ye knows of seven (lecture, Australian National Gallery, Canberra, June 4, 2000).

15 In a telephone conversation with the author on June 28, 2000, Xu Bing explained the various titles and their order.

16 Quoted in the Associated Press, *China from the Long March to Tiananmen Square* (New York: Henry Holt, 1990), 313.

17 See Yang Chengyin, "'Xin chao' meishu lun gang" (A discussion of the main principles of the "New Wave" of fine arts), *Wenyi bao* (Literature and art newspaper) (June 2, 1990), 5.

18 Ibid.

19 Letter from Feng Boyi to Xu Bing, June 8, 1990.

20 Du Jian, "Dui 'Xin chao meishu lun gang' de yijiang" (Discussion on "a discussion of the main principles of the 'New Wave' of fine arts"), *Wenyi bao* (Literature and art newspaper) (December 29, 1990).

21 Li Qun, "Duiyu 'Xin chao' meishu zhi wo jian—jiu shang yu Du Jian tongzhi" (My opinions of "New Wave" fine arts—A discussion with comrade Du Jian), *Wenyi bao* (Literature and art newspaper) (March 30, 1991), 6, as translated in Ma Yan, "A Reader-Response Analysis of 'A Book from the Sky': A Postmodern Educational Enterprise" (Ph.D. diss., University of Wisconsin-Madison, 1993), 463–64.

22 Transcript of interview between Lisa Pasquariello and Xu Bing, February 2, 1996, in Jennifer Grausman, Andrew Lohr, and Lisa Pasquariello, *Fractured Fairy Tales: Art in the Age of Categorical Disintegration* (Durham, N.C.: Duke University Museum of Art, 1996), 78.

23 Letter from Xu Bing to Michael Sullivan, September 25, 1997.

24 Hou Hanru, "Xu Bing, zai bing fengjian shang . . ." (Xu Bing, atop an icy pinnacle . . .), *Xiongshi meishu* (Lion art monthly) 5 (September 1990), 135.

25 Interview with the author, autumn 1991.

26 Wu Hung, *Transience: Chinese Experimental Art at the End of the Twentieth Century* (Chicago: David and Alfred Smart Museum of Art, University of Chicago, 1999), 34.

27 Letter from Xu Bing to Michael Sullivan, September 25, 1997.

28 Ma Yan telephone interview with Xu Bing, November 20, 1991. Ma Yan, "A Reader-Response Analysis of 'A Book from the Sky,'" 465.

29 Xu Bing discussed pig farming in a telephone conversation with the author, July 15, 2000.

30 Conversation with the author, October 1994.

31 *A Case Study of Transference*, prod. and dir. Ma Yingli and Ai Weiwei, trans. Kris Torgeson, New York, July 1994, videocassette.

32 Alexa Olesen, "Xu Bing: Twixt East and West," *Virtual China,* October 6, 1999 <http://www.virtualchina.com>

33 Xu Bing, introduction to *Introduction to Square Word Calligraphy* (self-published), 1.

34 Ibid.

35 Mao Zedong, *Talks at the Yenan Forum on Literature and Art,* 4th ed. (Beijing: Foreign Languages Press, 1967), 10.

36 Song Xiaoxia's interview with Xu Bing, February 2000.

37 Xu Bing, "Gaining Grass-roots Experience," in Maaretta Jaukkuri and Tuija Kuutti, eds., *DELICATE BALANCE: Six Routes to the Himalayas* (Kiasma, Finland: Kiasma Museum of Contemporary Art, 2000), 37.

FURTHER READING

Although a wealth of valuable material on Xu Bing's career has been published in Chinese and other languages, this annotated bibliography is limited to works in English.

Artist Essays and Interviews

Kaye, Nick. "Cultural Transmissions: An Interview with Xu Bing." *Performance Research* 3, no. 1 (1998): 44–51.
Xu Bing answers questions about the genesis and meaning of the *Book from the Sky* and *A Case Study of Transference.*

Olesen, Alexa. "Xu Bing: Twixt East and West." Virtual China (October 6, 1999). <http://www.virtualchina.com>
A sidebar in this article records an interview with Xu Bing in which he discusses the language confusion of the Cultural Revolution and his renewed drive to create in the service of the people.

Taylor, Janelle. "Non-Sense in Context: Xu Bing's Art and Its Publics." *Public Culture* (University of Chicago) 5, no. 2 (winter 1993): 317–27.
This interview focuses on Xu Bing's experiences during his first two years in the United States and his understanding of the American reception of the *Book from the Sky.*

Xu Bing. "To Frighten Heaven and Earth and Make the Spirits Cry." Artist's statement in *The Library of Babel.* Tokyo: NTT InterCommunication Center [ICC], 1998.
Xu Bing discusses how his peculiar relationship with language first developed over his years with his parents at Beijing University and then during the Cultural Revolution.

_____ . "Gaining Grass-roots Experience." In *DELI-CATE BALANCE: Six Routes to the Himalayas,* edited by Maaretta Jaukkuri and Tuija Kuutti. Kiasma, Finland: Kiasma Museum of Contemporary Art, 2000.
In this essay, Xu Bing thoughtfully examines his experiences in Nepal and changes in his life.

Other Texts

Abe, Stanley K. "No Questions, No Answers: China and *A Book from the Sky.*" *Boundary 2* 25, no. 3 (fall 1998): 169–92.
This essay dissects English-language criticism of the *Book from the Sky* through 1994, focusing particularly on ways in which cultural difference affected Western interpretations of the piece. An expanded version of this essay was published as "Reading the Sky." See *Cross-Cultural Readings of Chineseness: Narratives, Images, and Interpretations of the 1990s,* edited by Wen-hsin Yeh (Berkeley: Institute of East Asian Studies and Center for Chinese Studies, University of California at Berkeley,

2000). The same volume includes a response by Pat Berger, "Pun Intended: A Response to Stanley Abe, 'Reading the Sky.'"

Cayley, John. "Description of the Book from the Sky." Hanshan Tang Books catalog list 82. London: Hanshan Tang Books, 1997.
<http://www.hanshan.com/specials/xubingts.html>
The most careful and detailed examination of the *Book from the Sky* in terms of its fidelity to the format of traditional Chinese books is posted on this website. Cayley compares traditional layout, page design, binding, paper, font, and general structure with that of the *Book from the Sky.*

Duan Lian. "The Way from Outside In: A Pedagogical Study of the Chestyiakovian System of Teaching Drawing and Its Influence on Chinese Art Education." Master's thesis, Concordia University, Montreal, 1995.
A portion of this study is devoted to Xu Bing's innovative method of teaching drawing, which seems particularly remarkable given Duan's illuminating contextualization.

Erickson, Britta. "Evolving Meanings in Xu Bing's Art: *A Case Study of Transference.*" "Chinese Type" *Contemporary Art Online Magazine* 1, no. 4 (May 1998).
<http://www.chinese-art.com/volume1issue4/>
This essay focuses on Xu Bing's interest in the evolution in meaning of some works of art, including the *Book from the Sky* and *A Case Study of Transference.* Focusing on the latter, the essay traces the evolution of the piece's interpretation and notes various irrational responses to it. It is now republished in *Chinese Art at the End of the Millennium,* edited by John Clark (Beijing: Chinese-art.com, and Hong Kong: New Art Media, 2000).

_____. "Process and Meaning in the Art of Xu Bing." In *Three Installations by Xu Bing.* Madison, Wis.: Elvehjem Museum of Art, 1991.
"Process and Meaning" provides a good introduction to the work of Xu Bing, with a summary of the circumstances in China that led up to his emigration and a discussion of three major installations: *Five Series of Repetitions, Book from the Sky,* and *Ghosts Pounding the Wall.*

Gao Minglu. "Meaningless and Confrontation in Xu Bing's Art." In *Fragmented Memory: The Chinese Avant-Garde in Exile.* Columbus, Ohio: Wexner Center for the Arts, The Ohio State University, 1993.
As well as providing a precise summary of Xu Bing's career up to 1993, Gao Minglu describes *Cultural Negotiation,* an installation incorporating volumes of the *Book from the Sky* and *Post-Testament.*

Lloyd, Ann Wilson. "Binding Together Cultures with Cords of Wit." *New York Times,* June 18, 2000, sec. AR 35, 37.
Lloyd analyzes the reasons for Xu Bing's great success. She describes his projects for the year 2000, which included displaying Maoist quotes in the former Communist city of Prague, *Helsinki-Himalaya Exchange,* and the *Tobacco* Project at Duke University, in which he comments on the tobacco industry.

Ma Yan. "A Reader-Response Analysis of 'A Book from the Sky': A Postmodern Educational Enterprise." Ph.D. diss., University of Wisconsin-Madison, 1993.
This is the first text to comment extensively on the fact that the *Book from the Sky* is an open-ended work that elicits widely varying responses from different audiences. It also includes a wealth of primary material (thirty-four texts by Chinese critics on the *Book from the Sky* published from 1989 to 1991) translated into English.

Wang, Eugene Yuejin. "Of Text and Texture: The Cultural Relevance of Xu Bing's Art." In *Xu Bing "Language Lost."* Boston: Massachusetts College of Art, 1995.
"Of Text and Texture" discloses layered meanings behind *Can Series* in the context of an overview of the artist's career up to 1995.

Weintraub, Linda. "Allegorical Persona." In *Animal. Anima. Animus.* Pori, Finland: Pori Art Museum, 1998.
Focusing on *A Case Study of Transference* but also covering *Net and Leash,* Weintraub discusses Xu Bing's animal works. Other essays in this volume provide fresh perspectives on the relationship between humans and animals.

Wu Hung. "A 'Ghost Rebellion': Notes on Xu Bing's 'Nonsense Writing' and Other Works." *Public Culture* (University of Chicago) 6, no. 2 (winter 1994): 411–18.
In "A 'Ghost Rebellion,'" Wu Hung first peeled back layers of meaning inherent in *Ghosts Pounding the Wall,* examining the meaning of "ghost" in Chinese culture. He later developed this essay further by including an historical perspective on the meaning of the Great Wall. See Wu Hung, *Transience: Chinese Experimental Art at the End of the Twentieth Century* (Chicago: David and Alfred Smart Museum of Art, University of Chicago, 1999).

Yang, Alice. "Xu Bing: Rewriting Culture." In *Why Asia? Contemporary Asian and Asian American Art.* Edited by Jonathan Hay and Mimi Young. New York: New York University Press, 1998.
In her probing essay on the *Book from the Sky* and *Can Series,* Yang suggests that Xu Bing's works deconstruct elements of Chinese tradition in an effort to then construct a viable cultural language.

Yao Souchou. "Books from Heaven: Literary Pleasure, Chinese Cultural Text and the 'Struggle Against Forgetting.'" *Australian Journal of Anthropology* 8, no. 2 (1997): 190–209.
"Books from Heaven" points out several instances of unintelligible writing in Chinese culture and examines the role of language in twentieth-century China. It also questions why the *Book from the Sky* is such a powerful work of art.

Zhang Zhaohui. "Cultural Metamorphosis: The Art of Xu Bing and Cai Guoqiang." Master's thesis, Bard College, 1998.
"Cultural Metamorphosis" was prepared in conjunction with the exhibition *Where Heaven and Earth Meet*. Zhang is interested in the transformation wrought in Xu Bing's career due to his participation in the global art scene. Included are thoughtful examinations of the artist's early career and his current role as a "Confucian intellectual in the contemporary art scene."

CHINESE NAMES AND TERMS

哀	*ai*	美術研究	*Meishu yanjiu*
艾未未	Ai Weiwei	奇	*qi*
彼	*bi*	青草堂集	*Qingcao tang ji*
蔡錦	Cai Jin	桑葉	Sang Ye
彩育鄉	Caiyuxiang	世界美術	*Shijie meishu*
殘	*can* (to damage)	宋曉霞	Song Xiaoxia
蠶	*can* (silkworm)	素描訓練:廣義和狹義	"Sumiao xunlian: guangyi he xiayi"
地	*di*	天書	*Tianshu*
杜鍵	Du Jian	文化動物	*Wenhua dongwu*
段煉	Duan Lian	文藝報	*Wenyi bao*
馮博一	Feng Boyi	巫鴻	Wu Hung
馮夢波	Feng Mengbo	西	*xi*
分析世界的書	*Fenxi shijie de shu*	析世鑒-世紀末卷	*Xi shi jian—shiji mo juan*
高名潞	Gao Minglu	<<新潮>> 美術論綱	"'Xin chao' meishu lun gang"
公社的節日	*Gongshe de jieri*	雄獅美術	*Xiongshi meishu*
狗	*gou*	徐冰	Xu Bing
古元	Gu Yuan	徐冰木刻小品	*Xu Bing's Small Woodcuts*
鬼打牆	Gui Da Qiang	徐冰，在冰峰尖上···	"Xu Bing, zai bing fengjian shang …"
心	heart *(xin)*	徐華民	Xu Huamin
侯瀚如	Hou Hanru	徐志偉	Xu Zhiwei
黃金萬兩	Huang jin wan liang	楊成寅	Yang Chengyin
花盆公社	Huapen Commune	一	*yi*
爛漫山花	*Lanman shanhua*	藝術家	*Yishujia*
力群	Li Qun	張朝暉	Zhang Zhaohui
栗憲庭	Li Xianting	招財進寶	Zhao cai jin bao
劉春華	Liu Chunhua	趙國華	Zhao Guohua
忠	loyalty *(zhong)*	正	*zheng*
馬剛	Ma Gang	中國美術報	*Zhongguo meishu bao*
馬焰	Ma Yan		

INDEX

Page numbers in *italics* refer to illustrations.